GW00771555

# ABANDONED
# EASTERN
# NEBRASKA
## RURAL WANDERING

## NICOLE RENAUD

AMERICA
THROUGH TIME®
*ADDING COLOR TO AMERICAN HISTORY*

America Through Time is an imprint of Fonthill Media LLC
www.through-time.com
office@through-time.com

Published by Arcadia Publishing by arrangement with Fonthill Media LLC
For all general information, please contact Arcadia Publishing:
Telephone: 843-853-2070
Fax: 843-853-0044
E-mail: sales@arcadiapublishing.com
For customer service and orders:
Toll-Free 1-888-313-2665

www.arcadiapublishing.com

First published 2020

Copyright © Nicole Renaud 2020

ISBN 978-1-63499-230-5

All rights reserved. No part of this publication may be reproduced,
stored in a retrieval system or transmitted in any form or by any means,
electronic, mechanical, photocopying, recording or otherwise, without
prior permission in writing from Fonthill Media LLC

Typeset in Trade Gothic 10pt on 15pt
Printed and bound in England

# CONTENTS

# 1

# PRAIRIE PEACE PARK

In the early 1990s, the peace park movement began to pick up speed across the United States. The goal was to create multiple public spaces throughout America to serve as world peace sanctuaries. In 1994, Prairie Peace Park was created off I-80 near the Crete exit in Nebraska. Over the years, the park received a significant amount of recognition, including a visit from actor Ed Asner, children's singer Raffi, and the late U.S. Senator J.J. Exon. Unfortunately, this was not enough. In 2005, the "war on terror" was in effect and the peace park movement was struck hard. The park then closed and was sold to the transcendental meditation group at Maharishi Vedic City.

Since then, the park has let many of its exhibits get ruined by the weather. The house has been destroyed by vandals and partiers. Floors are missing in some of the upstairs rooms, and part of the roof is ripped off on one side. The colorful paint that once covered the entire house is slowly fading away. The 27 acres of land that were once exhibits and trails is now just overgrown weeds.

Don Tilley, president of the Prairie Peace Park board had high hopes that the peace mission would live on after the board sold it in 2005 to the Global Country World Peace group based in Vedic City, Iowa. The group affiliated with Maharishi had planned to build a 12,000-square foot "Peace Palace" on the site to teach meditation and host public lectures. The project died from lack of funds. Now it still sits zoned as a commercial property.

One benefit of whoever owns the land that the park sits on is that they are legally required to preserve two of the sculptures in the field. You can see both of these still today if you walk down the grassy field behind the house as they face I-80. The first one is the "dance of the children," which is a metal globe sculpture with doves and children holding hands on its equator. The second is the world peace mural created from clay—a rainbow painting of handprints, sunshine, humans, flowers, and textures. This was completed by a team of thirty-four international artists.

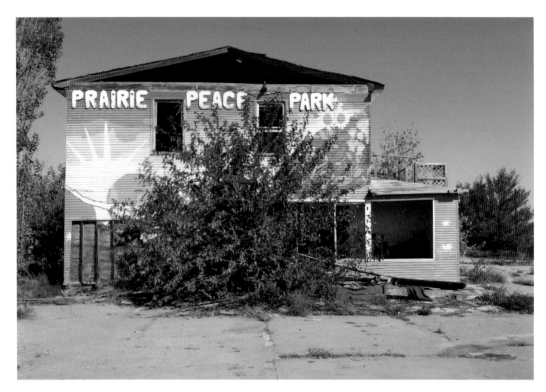

The Peace Park house the first time I visited in 2012.

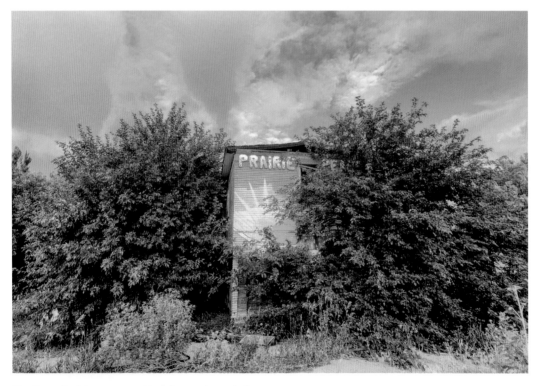

The Peace Park house covered in foliage at the end of summer.

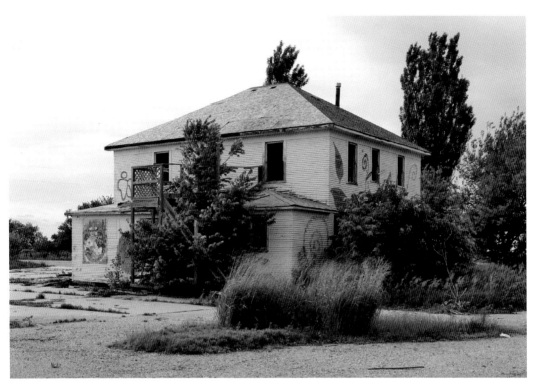

The backside of the house showing some of the colorful paintings.

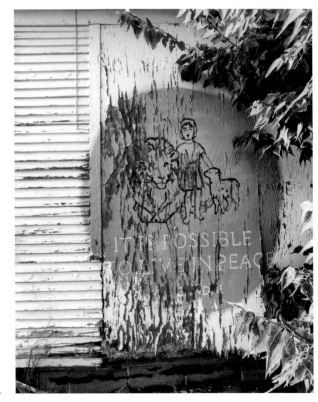

One of my favorite paintings on the south side of the house. "It is possible to live in peace," as Gandhi remarked.

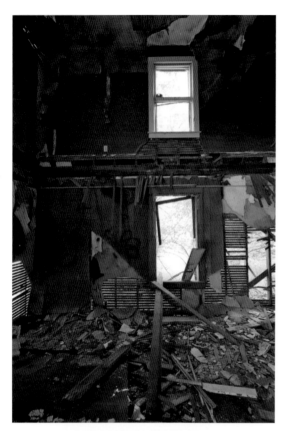

*Left:* Someone has removed the entire floor of one of the upstairs rooms.

*Below:* One of the upstairs bedrooms that had exhibits at one time. Someone tagged the wall "Eyes open eyes closed what we remember."

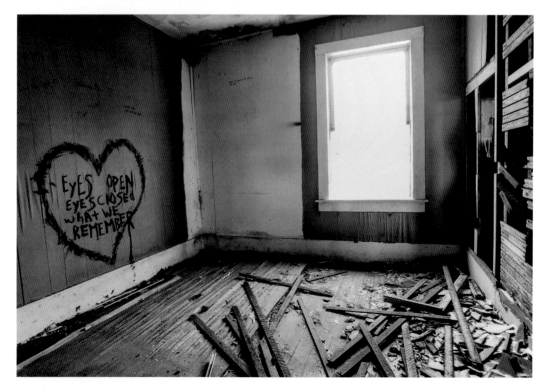

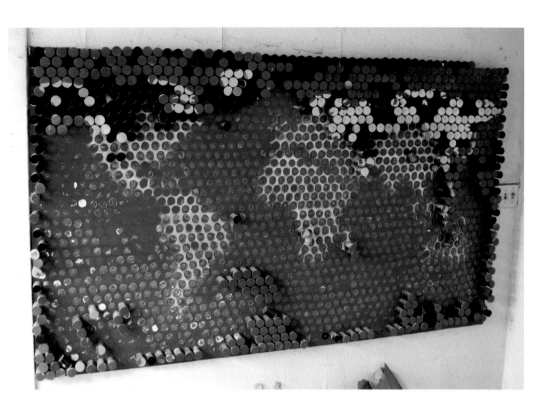

*Above:* What once was a world map made out of old film canisters.

*Right:* Rubble on the floor containing most of the canisters from the map.

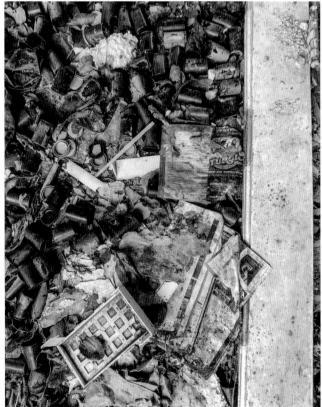

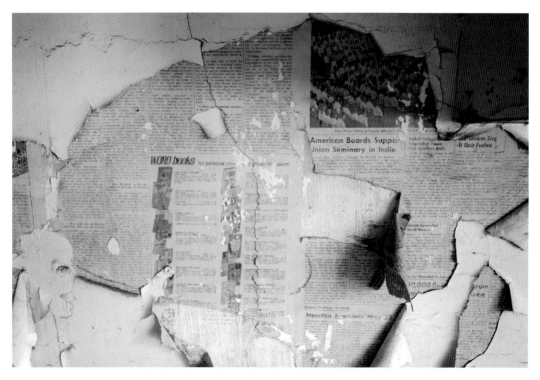

The walls in the kitchen were lined with old newspaper articles behind layers of paint.

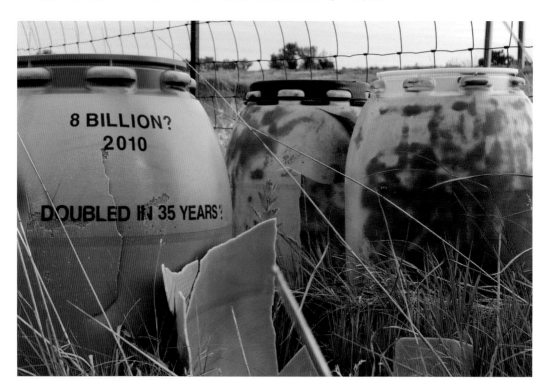

Giant barrels in the field that were once used for an exhibit on pollution. This was in 2012; the barrels can no longer be seen.

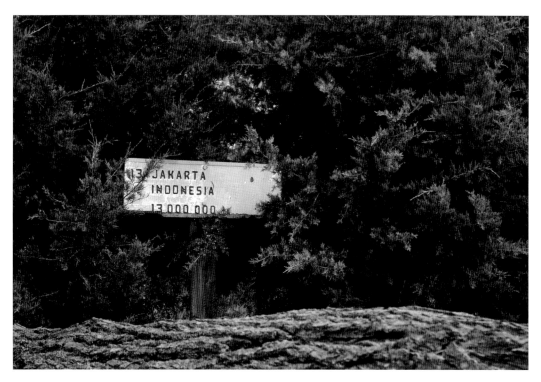

One of the signs remaining from an exhibit based on population. This was in 2012; these signs can no longer be seen.

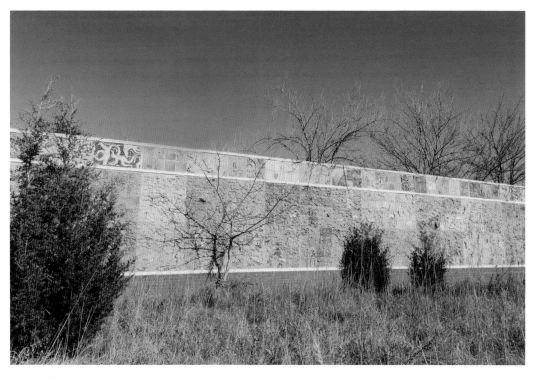

The massive clay mural wall that has to stay intact with the property.

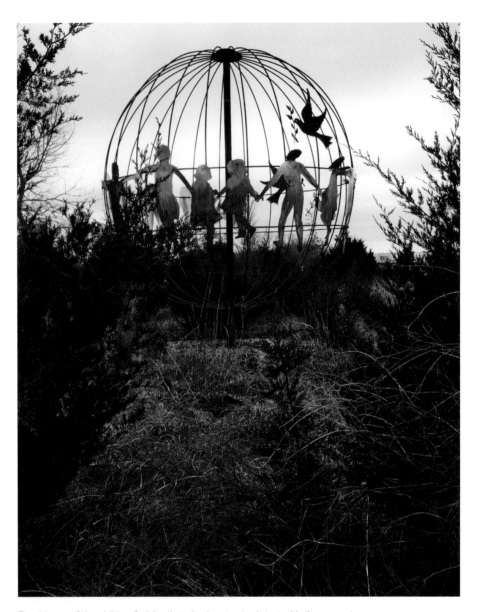

The "dance of the children" globe that also has to stay intact with the property.

# 2

# MILFORD INN AND WESTWARD HO! CAMPGROUND

The "teepee motel" west of Lincoln NE, off I-80, was actually the former Milford Inn, part of the Westward Ho! Campground at the Milford exit and directly across from the world's largest covered wagon. Kenneth Dahle, the same man who constructed the covered wagon gas station, also owned the adjoining motel and campground property on which he built two large wooden teepees to attract motorists. One teepee contained men's and women's restrooms along with showers, and the other was used as a spare motel room. The property also had several wooden cutouts of western-themed decorations including a buffalo silhouette, campground markers shaped as arrowheads, and picnic tables with painted-on Indian symbols.

In the 1960s, Kenneth had an 1800s-era schoolhouse and church moved to the side of I-80 a few yards down from the campground to act as tourist attractions. Inside the church were thousands of souvenir plates, cups, and various ceramic pieces that seemed to be left over from the general store and gift shop at the front entrance of the campgrounds. It was a barn-shaped building filled with little western-themed trinkets and an assortment of all the ceramics stamped with quirky Nebraska images.

The first time I explored the property more than just driving by was early 2012, shortly after the entire place was demolished; the church, general store, teepees, and a house were completely gone. It left an area of beautiful memories to be forgotten, only remaining photographs to prove what once was. If you drove by now, you would have no clue what a special place it was. Although the world's largest covered wagon is still around on the opposite side of the road, the rest of the property is now a machinery supply company.

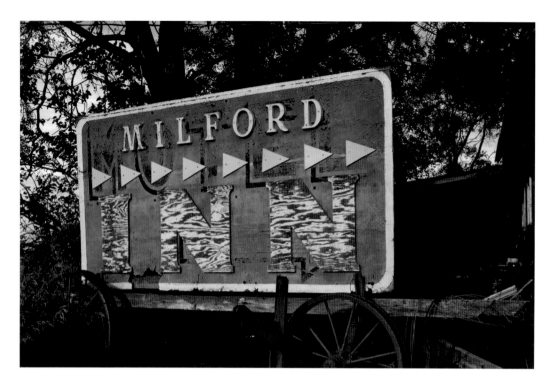

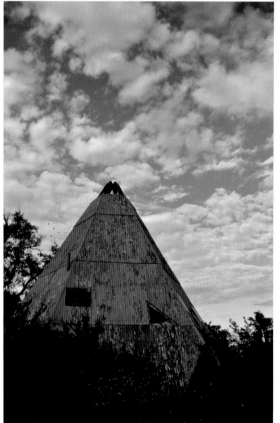

*Above:* The sign from the motel that had already been demolished.

*Left:* This was the restroom and shower teepee at camp Westward Ho!

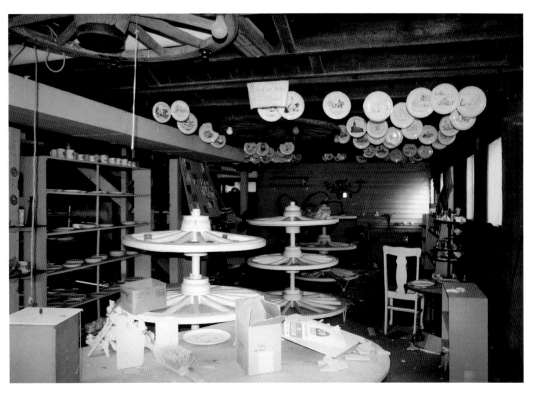

Inside the general store and gift shop showing the array of plates.

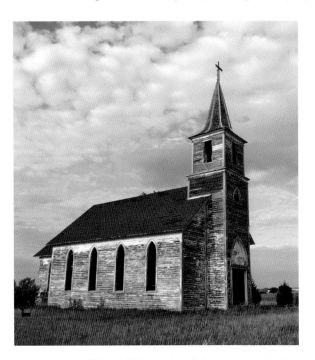

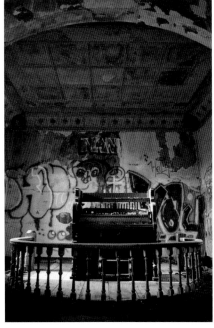

*Above left:* The 1880s-era church that was moved to the property in the 1960s.

*Above right:* Inside the church, showing the graffiti from years of sitting abandoned and the broken pump organ.

# 3

# SANDPIPER COVE

In 2011, the Missouri river flooded pretty badly, leaving the area of Sandpiper Cove abandoned and forgotten to be taken over by vandals and the homeless. This cove sits adjacent to Freedom Park, which is an outdoor tourist museum with valuable military artifacts, including the USS *Marlin* SST-2 submarine and USS *Hazard* AM-240 minesweeper as well as a jet fighter and other aircraft. The road that it sits on is long and narrow all the way down to the river, making it very hard to access by police in a hurry. It is very secluded, so people resorted to getting there by water to steal items from the museum and destroy Sandpiper Cove.

What once was a hot spot for boat goers is now unrepairable. On the property were multiple boat docks, a service center, a few houses, multiple outdoor use areas, and a restaurant bar to enjoy after having your boat out all day. City ordinances of Omaha, Nebraska, have it as a nonconforming use property, which makes it tricky in figuring out the plan of action with the ongoing damage and disrepair. In 2016, almost an entire homeless community made living arrangements in the old restaurant; as of 2017, they were all moved on and the place was a ghost town once again. Freedom Park has reopened with its normal seasonal weekend type hours, but the city of Omaha still struggles with keeping vandals and thieves out.

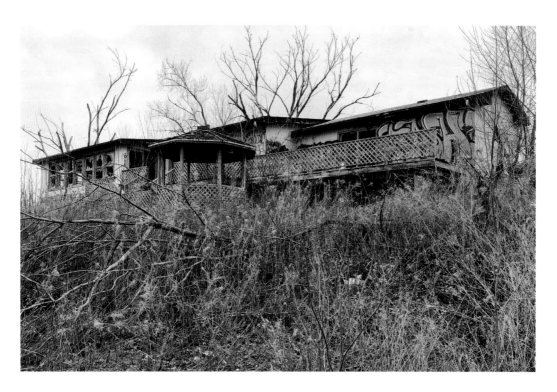

*Above:* An abandoned house connected to Sandpiper Cove.

*Right:* The boat docks that connect to the cove behind the house.

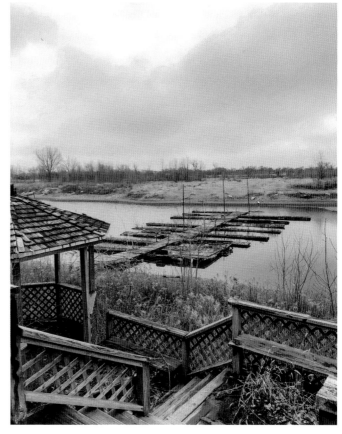

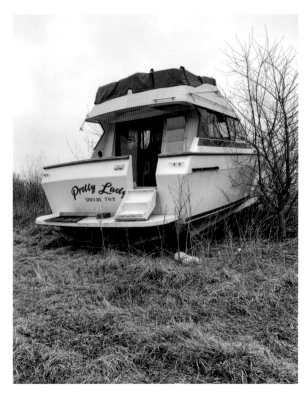

*Left:* One of the boats that never got picked up by its owner when they closed the cove.

*Below:* The service center connected to the cove.

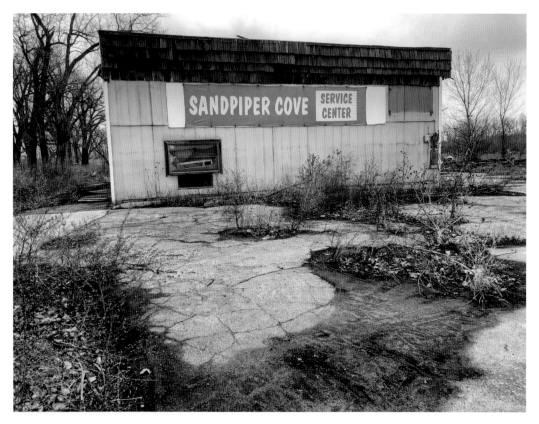

# 4

# DEVILS NEST

D evils Nest is a development along the Lewis and Clark Lake, northwest of Crofton, Nebraska. The original development (including the ski lifts) launched in 1970. The idea for this sparked in the 1960s to turn 3,000 acres into a private year-round resort and housing development, including a twenty-five-story hotel, a ski and hunting lodge, campgrounds, a golf course, a marina, a bridle path, and tennis courts. They broke ground in 1970, and by 1972, the ski lifts were open; the yacht club, equestrian center, and eight houses had also been built.

The momentum did not last long as financial trouble soon ended the development. By 1977, the property was sold at auction to satisfy judgements. Later on, the owners floated plans to renew the development, but nothing ever made it past the planning stages. Then over the years, some of the land has been sold off to neighbors.

The ski lifts and chairs were left to slowly rust away while the ski lodge and yacht club slowly deteriorated. Some of the nearby residents never stopped believing that it would make a comeback because of how neat the area is. There are tons of wildlife, spots to go fishing, endless trees, and a view for miles.

In 2008, Monda Kohles and five other partners bought the property, hoping to bring it back to life. They have learned the ins and outs of planning and have scaled down the plans a bit, but they still have high hopes to turn it around. In the early 1980s, Kohles had a camping trip with four friends in which they snuck onto the property and spent the night in the abandoned yacht club. She visited Devils Nest again ten years later and fell in love with the beauty and possibilities.

Kohles and the other developers are trying to do this process in steps rather than all at once, like they tried the first time; they are hoping that if they do it one step at a time, it will not get overwhelming or blow the budget. Kohles said, "To me, historic Devils Nest is a vital piece of history in northeast Nebraska." It is a piece of history that, after past failures, appears to be headed for a bright future.

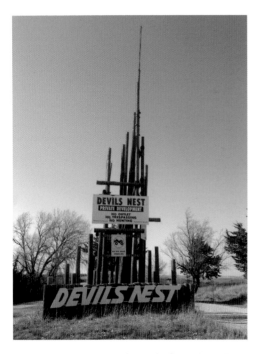
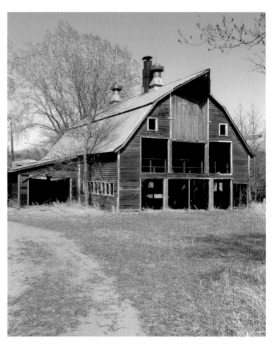

*Above left:* The entrance sign to the Devils Nest development, which also leads you to any of the homes in the area of windy roads.

*Above right:* The old ski lodge barn, which has since been remodeled to hold receptions and parties.

*Below:* Part of the board showing the ski routes.

| SHOPS & REPAIR DIRECTORY | | •HOTEL & MOTEL DIRECTORY | |
|---|---|---|---|
| | | BLOOMFIELD, NEBR. | 402 |
| | | FOUR SEASON MOTEL | 373-2441 |
| CROFTON, NEBR. | 402 | CROFTON, NEBR. | 402 |
| UPPER MISSOURI TRADING POST | 388-4844 | ROGNERS CROFTON HOTEL | 388-4155 |
| OMAHA, NEBR. | 402 | VERMILLION, SO. DAK. | 605 |
| LINCOLN, NEBR. | 402 | YANKTON, SO. DAK. | 605 |
| SIOUX CITY, IA. | 712 | | |
| SIOUX FALLS, SO. DAK. | 605 | | |
| | | CROFTON, NEBR. | 402 |
| OR SPECIFIC EQUIPMENT REPAIR OR SUGGESTIONS | | YANKTON SO DAK | |

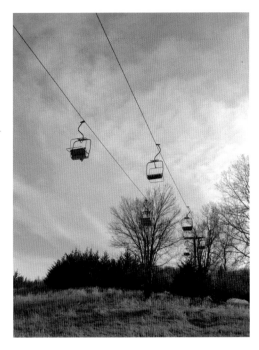
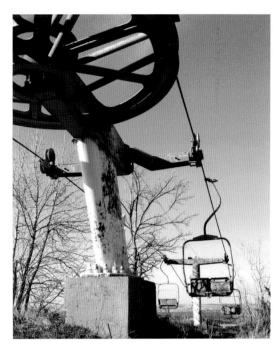

*Above left:* Looking up at the lifts from the bottom of the hill.

*Above right:* The end of the lift at the top of the hill.

*Below:* Another view from the top of the hill.

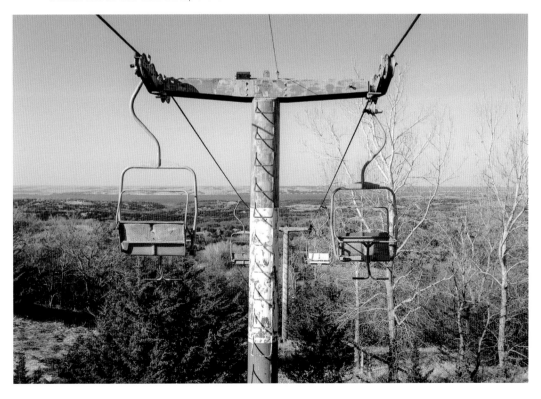

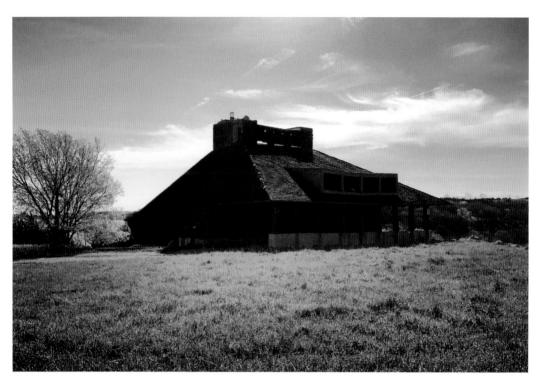

The exterior of the yacht club, which is across the road from the ski resort.

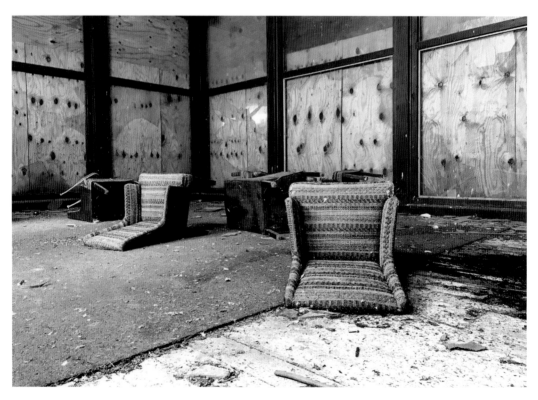

Inside the yacht club, which was all decked out in furniture from the 1970s.

# 5

# DANA COLLEGE

Dana College in Blair, Nebraska, was open from 1884–2010. The Trinity Seminary was opened in 1884 by the Danish Evangelical Lutheran Association in the home of Reverend E. C. Anderson. Its purpose was to train young men for the ministry. In 1899, Elk Horn College (a Danish folk high school from Iowa) was merged with Trinity. The co-educational Dana College and Trinity Seminary now offered seminary, pre-seminary, academy, normal, commercial, conservatory, and college departments.

It was not until the 1910s that Dana began to award associate's degrees and not until the 1930s that the school was accredited to award bachelor's degrees. The oldest student group on campus was the student Christian Association. In 1956, Trinity Seminary merged with Wartburg Seminary at Dubuque, Iowa.

Dana then turned into a liberal arts college for the rest of its days. In the twenty-first century, Dana College began to experience financial problems. In July 2010, after trying to sell to a group wishing to convert the school to a for-profit college with a significant online presence, Dana closed its doors. At the time of closure, the school had around 550 students and a 128-acre campus with fifteen buildings.

Argo and Elkhorn Halls were two of the dormitories on campus—Argo for women and Elkhorn for men. These were the two main buildings we spent our time in at the college as they have been known to be haunted. Argo hall had a number of haunting reports of electrical appliances that would turn on and off by themselves. Shadowy figures were spotted in the Charles A. Dana Hall of science and in the Mason Fine Arts Center. Witnesses have heard the phantom sounds of a piano playing and have seen dark figures. A suicide took place in Elkhorn Hall on the fourth floor in the 1930s, which many say are to blame for the sounds of the footsteps and voices heard there.

Since Dana closed in 2010, it has sat empty decaying away. Slowly being damaged by nature and vandals. In early 2018, an Omaha developer bought the campus for

$3.5 million. He donated the college to an organization planning to offer housing and programs to low-income elderly people, young people aging out of foster care, and others. The campus will be renamed "The Frank and Jane Krejci Life and Learning Center." Later campus developments would include serving military veterans and women who have completed heartland family services' Nebraska family works program. In November 2018, Argo and Elkhorn Halls were demolished so the pictures I am going to share with you from my time here are all that is left.

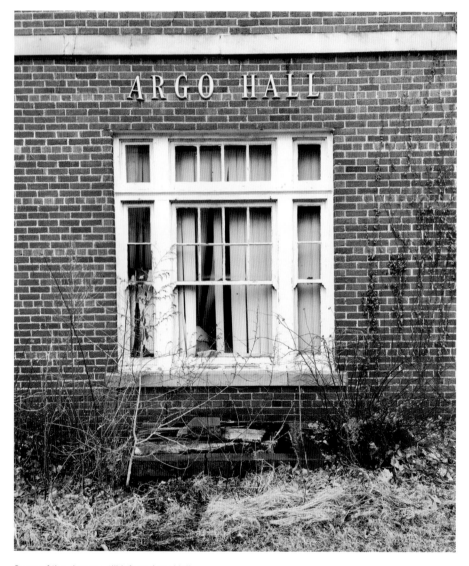

Some of the signage still left on Argo Hall.

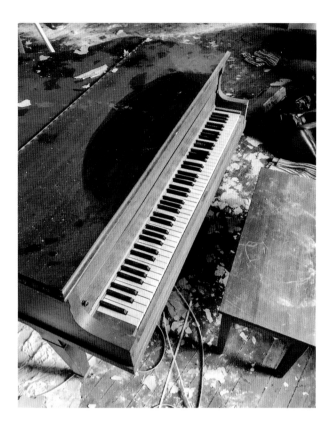

The piano inside the music hall.

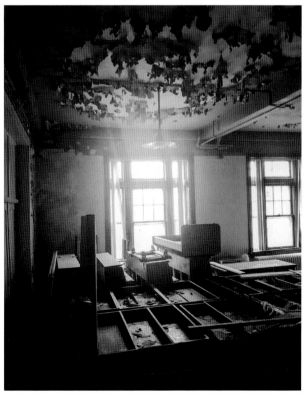

Part of the main room; you can see
how badly the paint has peeled.

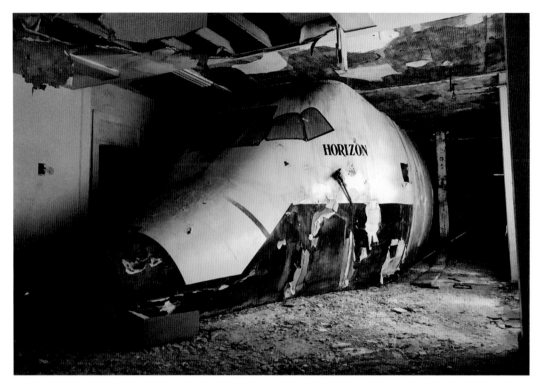

The space shuttle replica in the lower level of Elkhorn Hall.

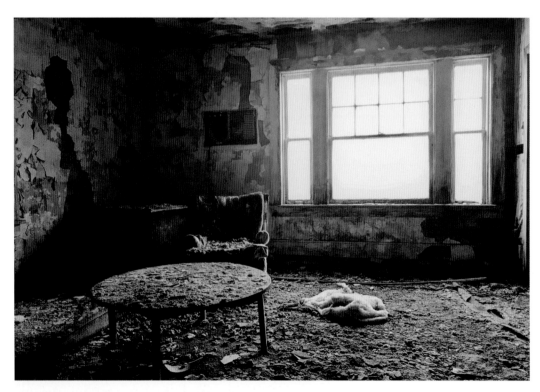

An upstairs dorm room has been taken over by water damage.

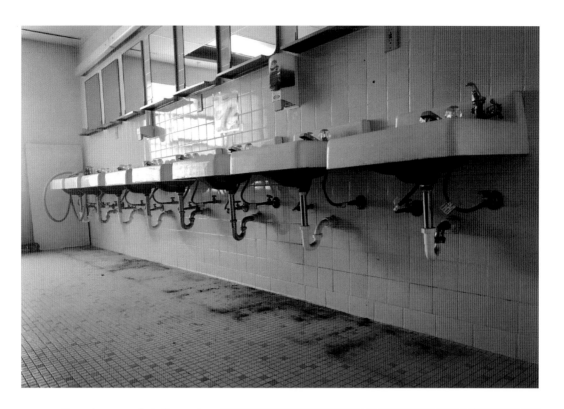

*Above:* A community bathroom in Argo Hall.

*Right:* One of the staircases in Argo Hall.

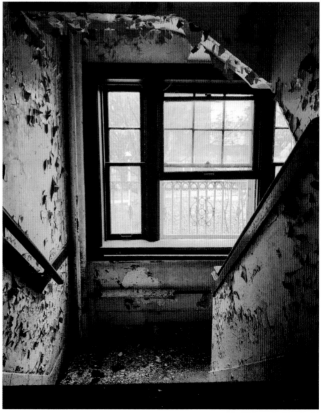

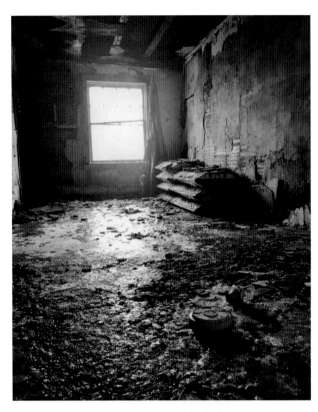

Another dorm room that has been taken over by damage.

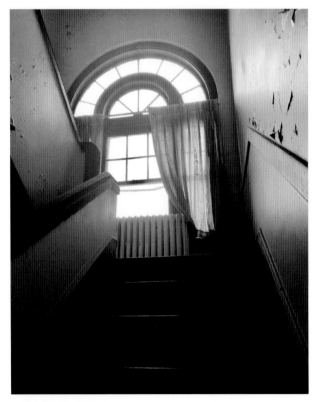

This staircase up to the top floor was one of my favorites.

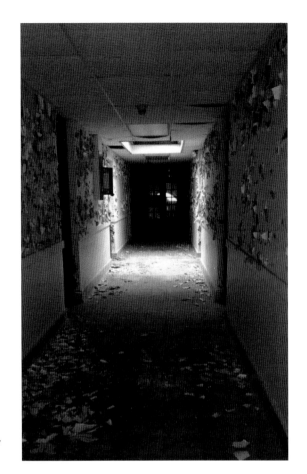

*Right:* Peeling paint in one of the hallways.

*Below:* The former football field where many people still come to exercise.

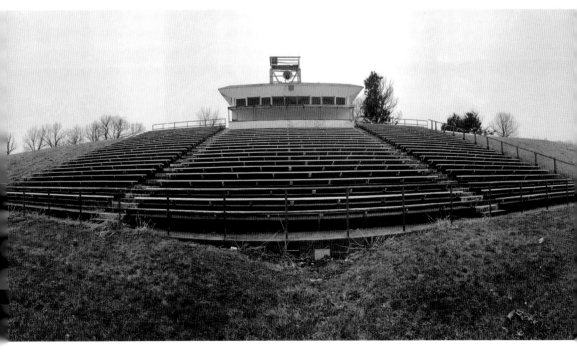

# 6

# MILFORD MILL

The mill sits just off the Blue River in Milford, which only became the town name because of the mill. J. L. Davison built the limestone dam across the river in 1867; this commenced the erection of the gristmill. There was also a sawmill not far from this one that was completed a few months later. I have not been able to locate it to this day, so I am unsure whether it is still around.

Milford is the oldest town in Seward County, serving as the first county seat until 1871. Milford was famous for the Shogo mineral water springs and the Quenchaqua flour mill (1867–1934). In 1877, several Ponca Indians passed through Milford when the government forced the tribe to move from their Nebraska homeland to an Oklahoma reservation.

This mill is one of my favorites because of the unique cement footings and structures around the entire property that surprisingly still remain. The main building is dangerous and crumbling, which is what adds so much character. The steps leading down to the mill are broken and uneven limestone where you have to take big steps to go up each one.

Once you get inside the main building, you will notice every wall has been covered with graffiti. If you look above to the roof, half of it is completely missing with some of the remains inside. There are a couple circular holes in the floor, which if you fell through would lead to the river, so I would assume a gear or machinery would have been placed in there.

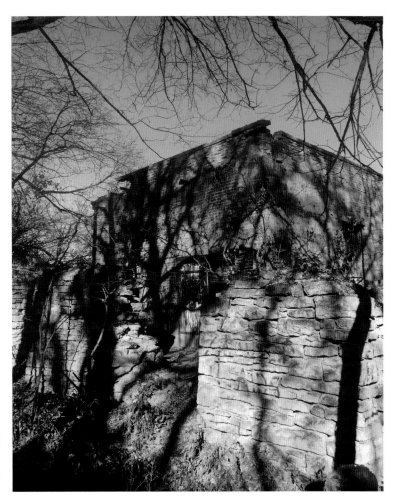

The exterior of the mill looking at it from the steps you have to take down to it.

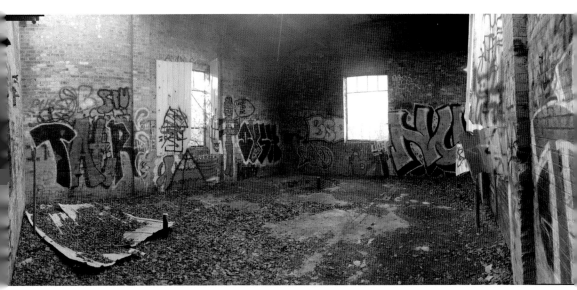

Panoramic shot of the interior that has been covered with graffiti over the years.

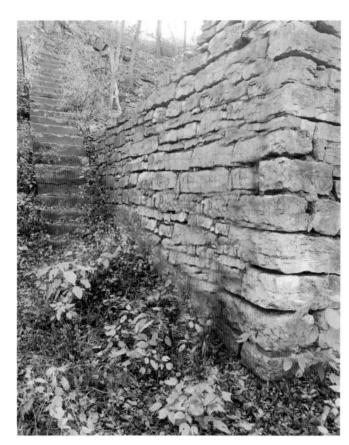

*Left:* Looking up at the steps at mill level, these steps lead you away from where the mill sits.

*Below:* Looking at the crazy cement structures leading to the mill, which I am not really sure what process these helped with when it was active.

# 7

# BLUE SPRINGS HYDROELECTRIC PLANT

The hydroelectric plant is also just off the Blue River in the small town of Blue Springs. Built in 1923 to power the area, it underwent several changes of ownership before becoming part of the consumers public power district.

The plant sits on the former location of the old flour mill. In 1881, there was a flood that caused significant damage to the mill, and it was unable to be saved. Burlington Railroad attempted to purchase it and move the remains to Wymore, NE, but local citizens urged Union Pacific Railroad to acquire the remnants to keep it in Blue Springs.

Walking up to the plant, you can access it from one side or you can go down to the river on the other and get a unique look at it from across the water. Many people go to that side of the river to catfish, which is where I have run into people when visiting the plant. Everyone always says how good the fishing is over there and they have usually traveled from another town.

The hydroelectric plant is very unique compared to other similar places I have been to because most of the gears and machinery are still intact inside. They are very bright and colorful as well. It is a bit of a climb to get inside as it is high up and the original steps have been removed, but once you are inside, it is worth the struggle. The view of the river from inside is also amazing.

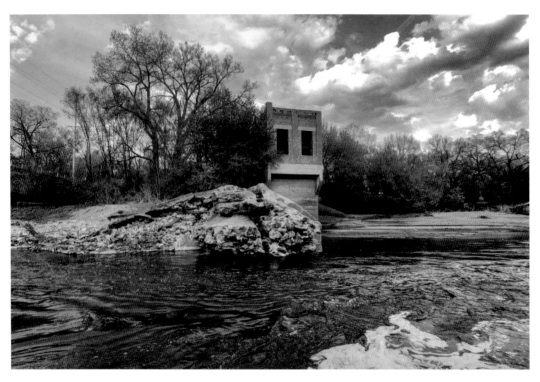

A summertime view of the mill across the river; this is where people come to catfish.

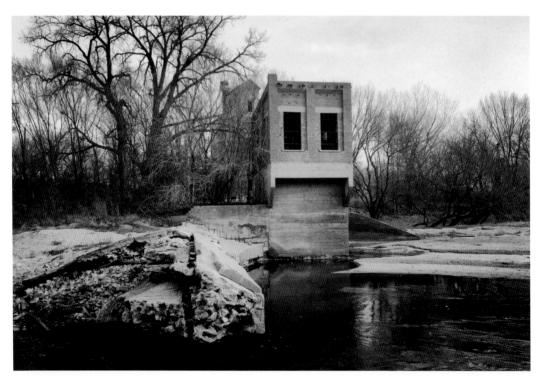

A similar view to before but in the winter; the change of seasons really shows how transparent the trees become, making the entire building in the back visible.

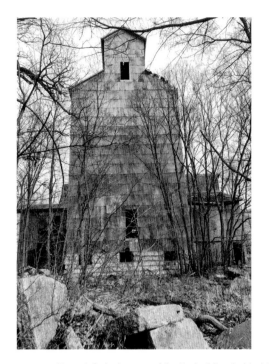 

*Above left:* A close-up of the tin building behind the mill that is filled with gears and equipment from when the plant was up and running.

*Above right:* One of the graffiti pieces inside.

*Below:* Inside the mill, all of the gears and machinery remain, which is pretty awesome.

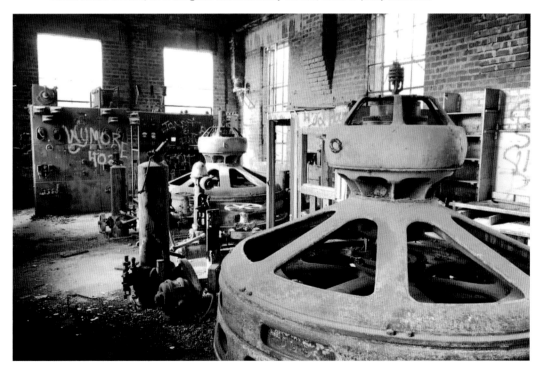

# 8

# NAVAL AMMUNITION DEPOT

This depot located in Hastings is one of Nebraska's four former major ammunition plants. The construction began in July 1942 on 49,000 acres and was completed in early 1943 with over 2,000 buildings, bunkers, and various other types of structures. The cost of construction was over $71 million.

The navy built on this location due to the proximity of the areas three railroads; the amount of underground water, cheap natural gas, and electricity; the stable work force; and the distance from either coast. At one time during World War II, the facility was producing over 40 percent of the U.S. Navy's munitions.

Production peaked in 1945 when the depot employed 125 officers, 1,800 enlisted men, and 6,692 civilians. This greatly affected the population of Hastings with a forty percent increase. In 1944, workers base wages were seventy-four cents an hour, with time and a half for overtime beyond fifty-four to sixty-four-hour work weeks. This caused farmers to experience a severe labor shortage, schools were over-crowded, and new homes were scarce.

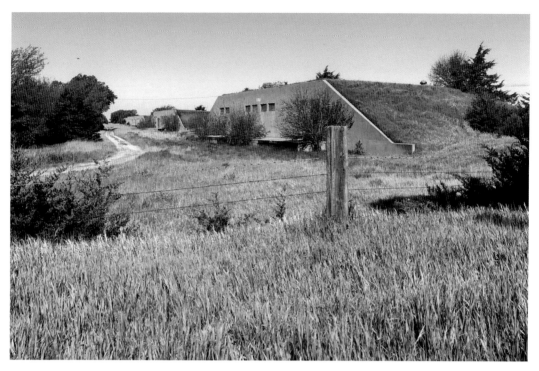

A few of the bunkers—there are over 2,000 of them on site.

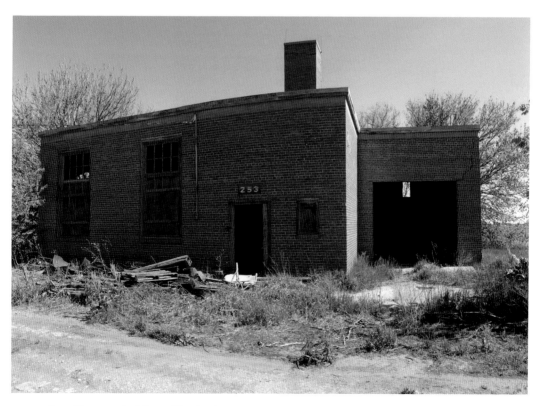

One of the many buildings of the depot.

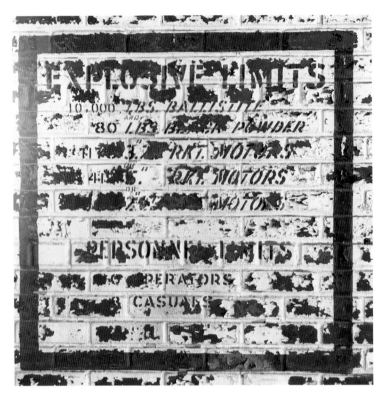

Hazardous signs remain painted on the walls.

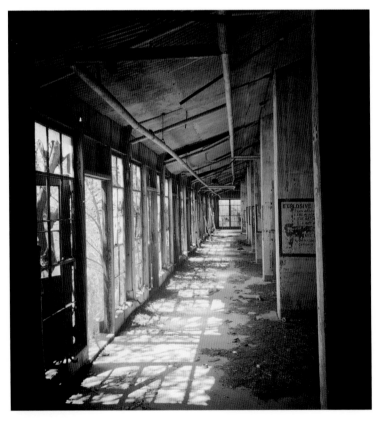

A hallway shot showing a row of the stalls; each stall was numbered still.

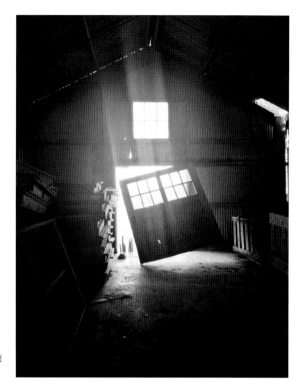

*Left:* A crazy door barely hanging on in one of the buildings.

*Below:* "Bye" painted on the wall in the building that looked to be the luncheon hall.

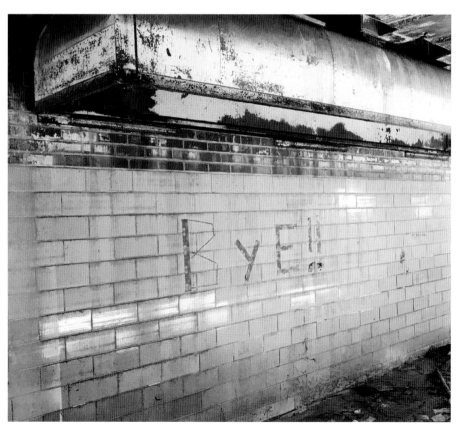

# 9

# SLAUGHTERHOUSE AND MEAT-PACKING PLANT

This massive slaughterhouse in the heart of Nebraska is high up there on my list of most difficult explorers ever, mainly because of the terrible things that went on here years ago and because I am a vegetarian. You would like to think where your food comes from is humane and sanitary, but after exploring a building like this, you begin to realize otherwise.

I was unable to find much information on when the facility was in operation and when it finally closed down. By the looks of the machinery and the items left in the administrative office, I would assume it closed in the 1980s—from the wood paneling on the walls to the very dated computers and safety training tapes to the machinery ran by foot petals instead of handles.

They did a fairly good job of cleaning the place out before shutting down; most of the furniture is gone and there are no animal remains laying around except for a couple of hoof bones. It seems that most of the machinery was left behind based on the layers of dust covering everything. The basement was very dark and dingy with signs of water damage as some areas of the floor were covered in standing water.

This massive complex had floor upon floor of dark staircases and hallways that led to a lot of rooms for varying things of the operation. There were conveyor belts running from the processing plant to what looked to be the refrigeration area and holding room before the meat would get picked up and distributed.

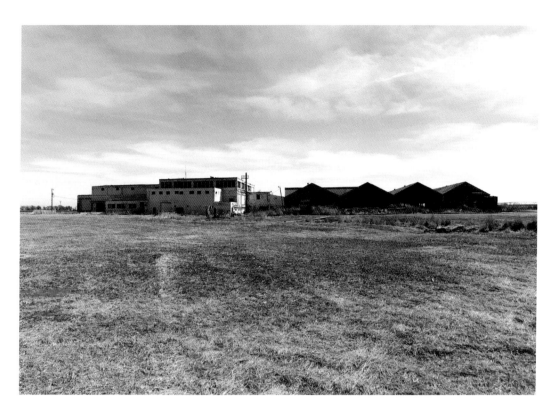

*Above:* An exterior view of how massive this place is.

*Right:* This was behind the slaughterhouse. I am not sure what is was used for; it may have been water storage at one point.

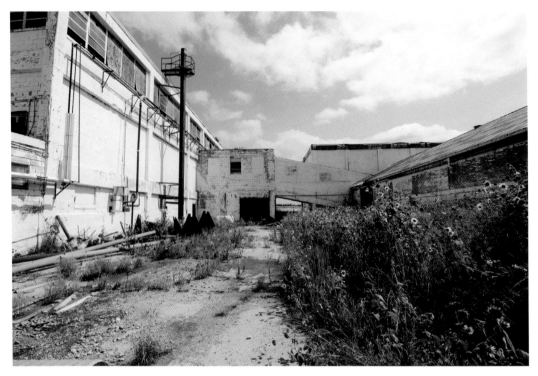

This raised area that connects the two buildings shows where the cows would walk from the holding area to the slaughter area.

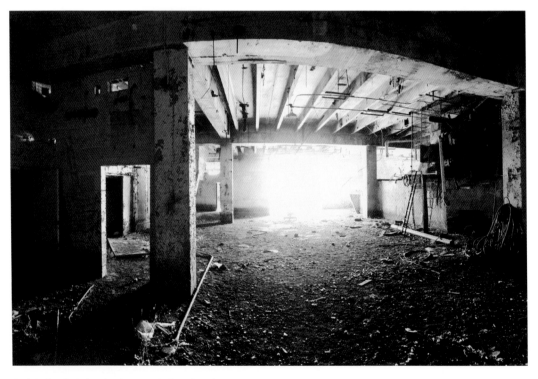

An interior shot showing how crusty the place is.

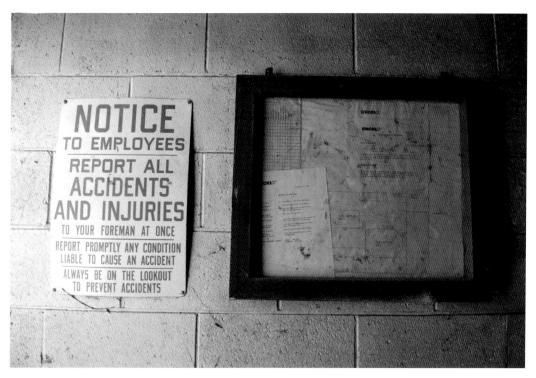

This notice warning and glass-protected paperwork was right inside one of the doors we entered. The date on one of the papers is October 21, 1987.

Another shot of one of the rooms. This place was so massive it was hard to tell what each nook and cranny was used for.

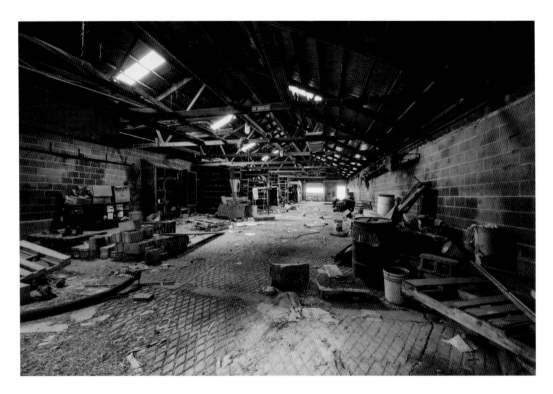

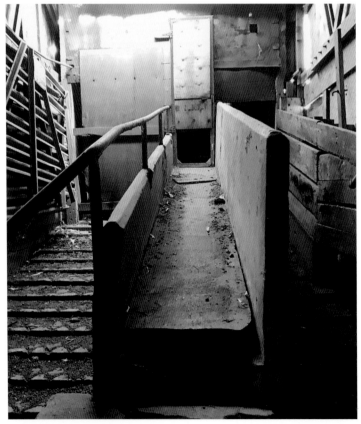

*Above:* This was the maintenance room, which was right around the corner from death row and the holding barn.

*Left:* Death row as we like to call it. I could not believe how small it was.

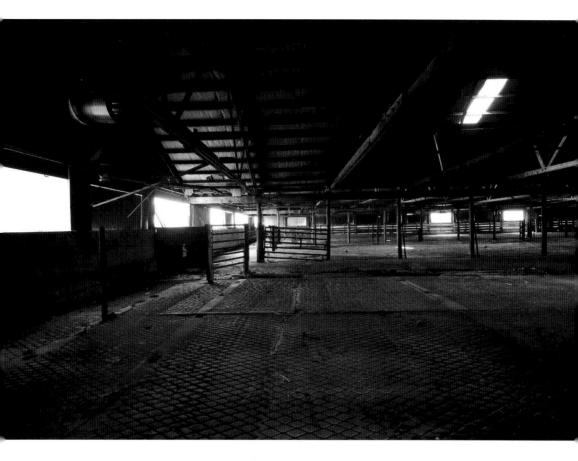

*Above:* This was the holding barn with stalls where the cows were kept until slaughter.

*Right:* Looking out of the barn and seeing the wide-open field makes it hard to believe the terrible things that went on here.

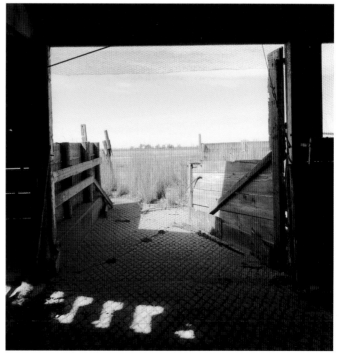

# 10

# SKY WAY DRIVE-IN THEATRE

The theatre in Schuyler opened on July 9, 1970, with a double feature of *True Grit* and *El Dorado*. All that remains is the screen and the ticket booth. The projection booth and the concession stand has been torn down. I do not have a clue of when the theatre closed for good, but there have been stories that it is a haunted place. Tales of a one-eyed dog with a missing leg wandering around have been reported.

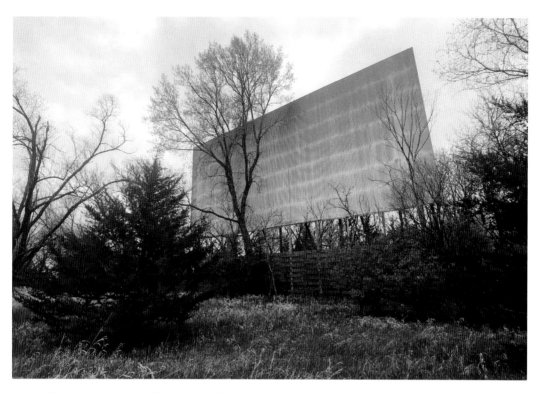

The viewing screen is still in great condition minus being surrounded by trees now.

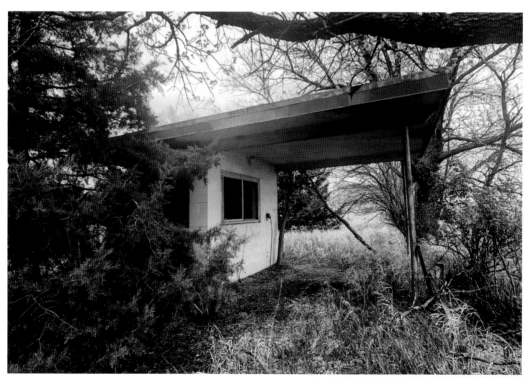

This cute little shack is where you purchased tickets.

# 11

# RANDOLPH CAR WASH

The Randolph car wash was an iconic place in Lincoln for many years, and locals were very upset to see it go. It opened in 1967 and was the oldest most recognizable full-service car wash in town. When you Google the car wash, all the wonderful reviews still pop up; it is heartwarming to see how many people really loved this business.

In the summer of 2018, it was sold to a developer who would level it to make room for condos. Sadly, they moved pretty quickly with the demolition, and I was only able to get the one photo. The signage across the top of the building was pretty remarkable. The signage on the corner street was also pretty perfect for its age, and last I knew, it was auctioned off, so we can only hope it was saved.

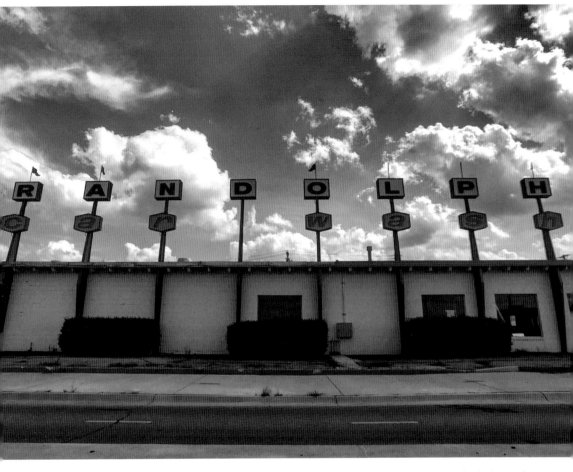

The only photo I was able to get before this beauty was demolished—a true Lincoln icon. The sign is absolutely stunning.

# 12

# WHEAT GROWERS HOTEL

The Wheat Growers Hotel in Kimball was built in 1918 and was the largest hotel in town. The builder, F. Cunningham, had it recognized as the most glamourous hotel between Omaha, Nebraska, and Denver, Colorado. The wheat theme and details on the exterior celebrates an important facet of commercial and economic development of the city and country. The space had eighty-six rooms, a restaurant, and a ballroom.

Below the hotel kitchen lies a tunnel that connected to the speakeasy in town; the main use was to transport illegal alcohol. Story has is that years ago, a young woman became trapped in the tunnel for days without food and water. She ended up passing away in the tunnel. Some people say they can see her in one of the top story windows like her spirit never left the hotel.

In 1925, the Moore family bought half the interest and became part-time managers; since then, the hotel has had various owners. In 1983, it closed its doors to the public. In 2002, it was placed on the historic register, which is great but that still does not prevent it from being torn down. The current owners had grand plans for it, but time is taking a toll on the structure. The entire inside is gutted, so it is really just a shell of a building. I really hope someone can give it the love it needs.

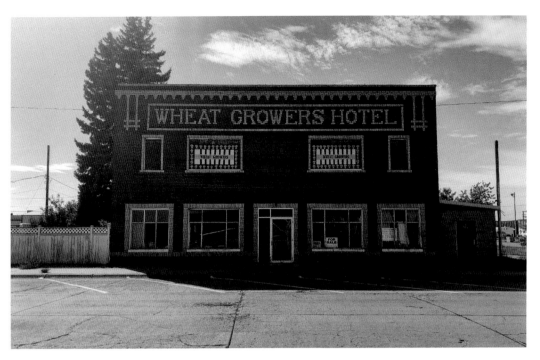

The exterior of the historic Wheat Growers Hotel.

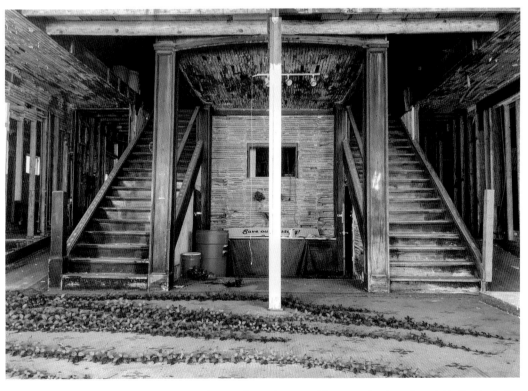

The view from the front doors shows the amazing staircase and the crazy vine from the outside that is starting to take over the inside.

# 13

# HOMESTEADS OF EASTERN NEBRASKA

**THE BRICK** was built in 1881 for Dave V. Stephenson. The brick used for this house and the church up the road was manufactured half a mile east of the home in a kiln there. The brick masons were Mike Branin, Howard Chester, and a man called Sprole. The carpenters were Tom Teneky and his brother, William. The church was known as Mt. Zion and it was of the Methodist religion.

After Stephenson passed, John Morehead lived in the home. Another man by the name of John Henry and his wife, Alta (Orr) Shafer, moved into the home in 1919 and raised thirteen children there. Only ten of them were born in the home. Dennis Lee Shafer, Sr., gave me this history of the home; he was born there in 1934. His father was the son of John and Alta, who lived there until 1945 when John retired. After that, his son, Charles, lived there until he retired, and then his younger son, Alfred, moved in until an unknown date, then finally a new family moved in for a few years and are the ones who left it abandoned and vacant.

This home is probably my favorite in Nebraska. I stop to see it a couple times a year. I will be sad the day I go and see that is has been demolished to make room for more corn. The very first time I went there, there were numerous out buildings and a barn on the property. Now all that remains is the house and the corn that gets planted around it. The roof is completely gone, making the inside almost unrepairable. You can see all the way into the basement from the damage that has been done without a roof. The reason the structure has lasted so long without a roof is because the walls are about four layers thick of those handmade high-quality bricks.

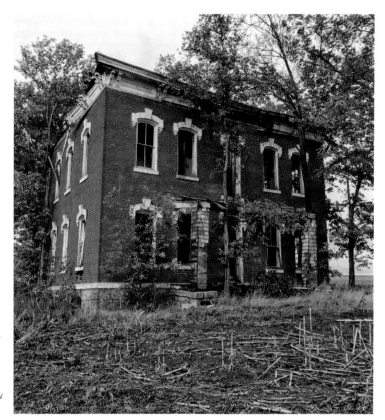

*Right:* "The Brick" as the locals like to call this massive house.

*Below:* A side shot of "The Brick." The window details are my favorite.

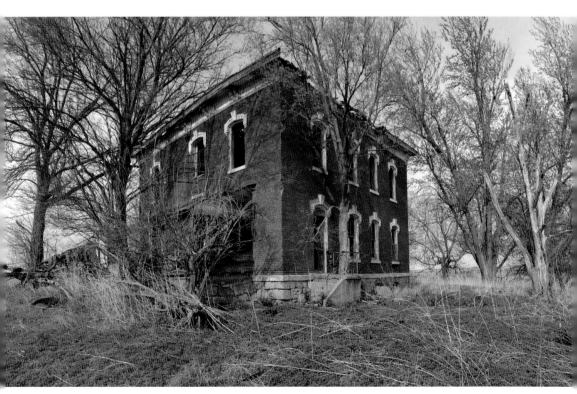

A close-up view showing the many layers of brick it took to build this house.

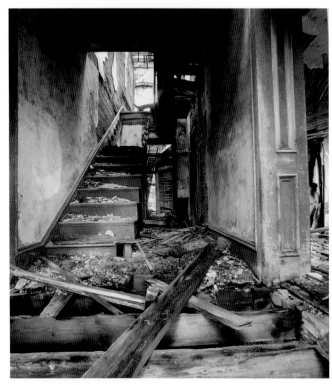

The interior is damaged pretty bad, but you can see how grand the staircase once was.

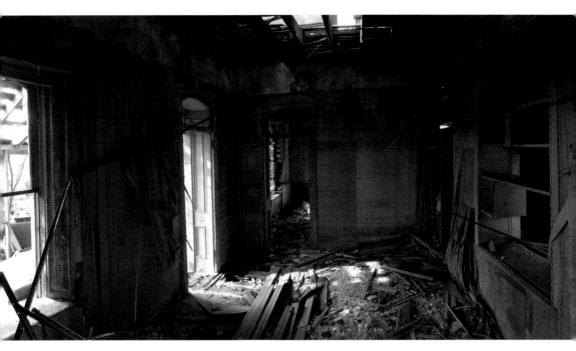

Another interior shot from the back of the house; I think this is where the kitchen was.

The first time I visited a barn and some stables were in the field; they are no longer standing and have been replaced with corn.

**THE BEETISON MANSION** is a pretty well-known and frequently photographed place here in Nebraska. It sure does have a lot of history behind it; it was built in 1874 and lived in by five generations of the same family.

The cupola was once a lookout for Native Americans, but now you can see the capital to the west and Omaha's woodman tower to the east. In 1977, it was placed on the National Register of Historic Places. It was last sold in 1999 out of the Beetison family and has since sat vacant.

The home was constructed out of 18-inch-thick limestone blocks that were dragged by horses and wagons nearly 10 miles across what is now I-80. The home covers about 1,800 square feet, and for a time, it was considered one of the largest homes in Nebraska. The Italianate architecture is one of the finest examples in the state.

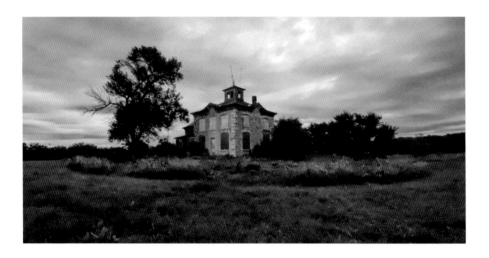

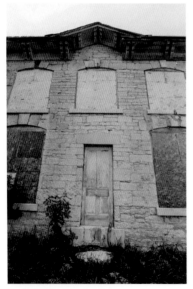

*Above:* A wide shot showing how well the owners of the golf course still maintain the Beetison property.

*Left:* Although the stonework is still in almost perfect condition, you can see how nicely they boarded up the windows to try and preserve things. Sadly, vandals have still done some damage.

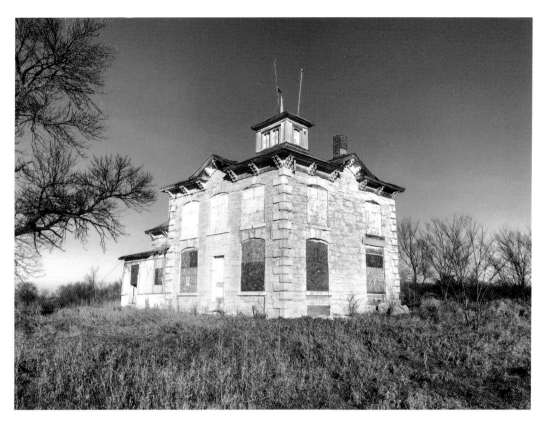

A close-up of this beautiful house; the stonework and all the details are stunning.

*Above left:* The wallpaper in the kitchen was super cute.

*Above right:* This is the view from the tower at the top, which has a very tiny and winding wooden staircase up to it.

**THIS OLD FARMSTEAD THAT SITS NEAR BROWNVILLE, NEBRASKA**, has caught my eye for the last eight years or so, though I never had the courage to go up the road to it because of how close it sat to a newer built home on the property. Finally, two years ago, I drove up to it and proceeded to knock on the door of the current lived-in home. I had no luck that day and have been back two other times to photograph it as well in hopes that the owner will be around. Unfortunately, that leaves me with no history on the place other than with the current state it is in. I am sure it has sat empty for decades. I just love how profound this home is and how intact the windows on the second story remain.

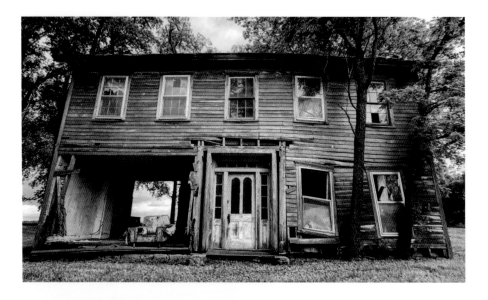

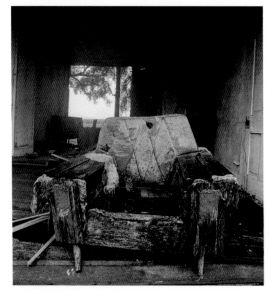

*Above:* The way this house looks to be leaning with all the glass windows is what caught my attention many years ago.

*Left:* A close-up of the lonely chair that just sits in the open part of the house.

**THIS FARMSTEAD NEAR SHUBERT** on your way to Indian Caves is another one that has always caught my attention. I have never been able to contact the owner to get specifics on the history, although the land around it is still being farmed every season. This little house sits pretty far off the road with a couple of out buildings and barns even further behind it. My guess is that it has been vacant for close to fifty years.

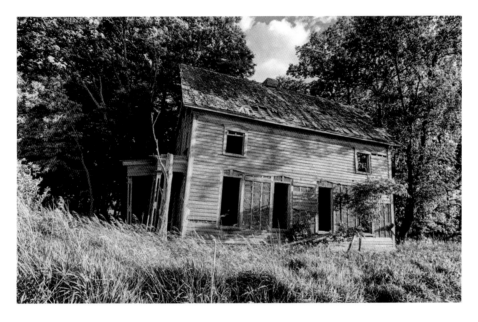

*Above:* This house looking super lush in the summer months.

*Right:* A different angle—the first time I photographed this house it was such a dark and gloomy day.

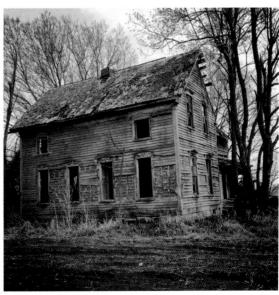

THIS FARMSTEAD NEAR MEAD had to have been pretty grand in its day given the size. You can easily miss this place driving down the highway with how green and lush she gets in the warmer months. I have a photo of this place from every season, and my favorite was from the winter when the owner had placed a vintage Christmas decoration in front of the house. Despite the condition of the house, someone still cares and tends to the land she sits on. Seeing that faded wood decoration made me so happy that someone takes the time to place it there year after year.

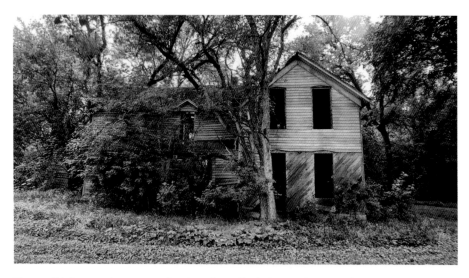

The way this house gets overgrown is astounding, with vines wrapping everywhere.

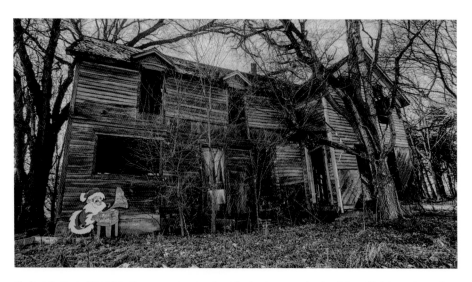

My favorite time visiting this place was when I noticed the landowner set out a vintage Christmas decoration.

THE SAATOFF HOUSE, which sits between Sumner and Miller, Nebraska, is well-known by a lot of people in the area. A lady by the name of Bernice taught piano lessons there in the 1950s and 1960s. Bernice lived in the home with her husband, Enden, then the house was sold to other families over the years; it was last lived in until around 2004. Many people talk about the beautiful staircase and woodwork inside, but unfortunately the current owner will not show the inside to anyone. It has been very well preserved on the outside, and almost all the windows and details are intact.

Some old folk tales about the "widow's walk" around the roof of the house are that prostitutes would go up there to look for men working on the rail line that was just to the north of the property. The other folklore about the widow's walk is that widows would go up there to look for loved ones coming home from war. It is crazy to think the stories that get created about these places over the years.

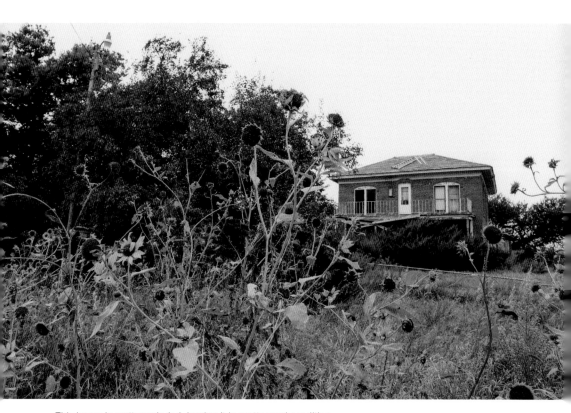

This house is pretty secluded, leaving it in pretty good condition.

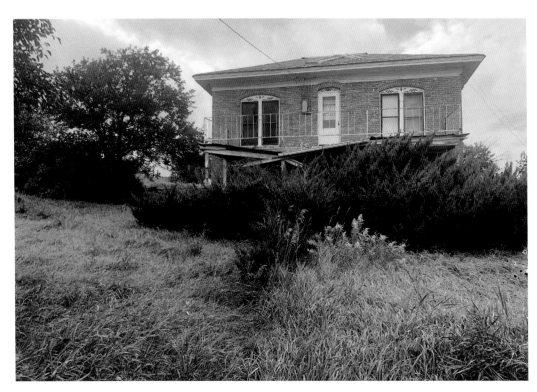

A closer look shows some of the window details and that the widow's walk has collapsed over the years.

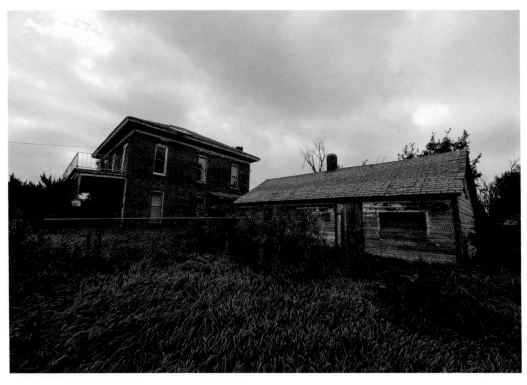

A side view showing more of the porch and garage.

**THE MARY ELLEN OBSERVATORY** is a homestead near Clarkson, Nebraska. Mary Ellen and Joe McNulty are the owners; Joe has passed away and Mary Ellen resided in Omaha until she passed away in January 2019.

This home is probably one of the most unique ones that I have come across. You would not guess that by the outside as it is just a simple one-story home with a brick exterior—nothing too fancy about it. The inside is filled with extravagant woodwork, crazy tiling, and wallpaper throughout.

The story behind this property is that Joe had a close encounter with aliens as a young man, and he built this place to listen to outer space. He spent the rest of his life trying to have another. All over the property lies strange remains of antennas and electrical paraphernalia. Inside was just the same large amounts of light bulbs and fixtures lying around. Joe had many books on antennas, electricity, and outer space as well.

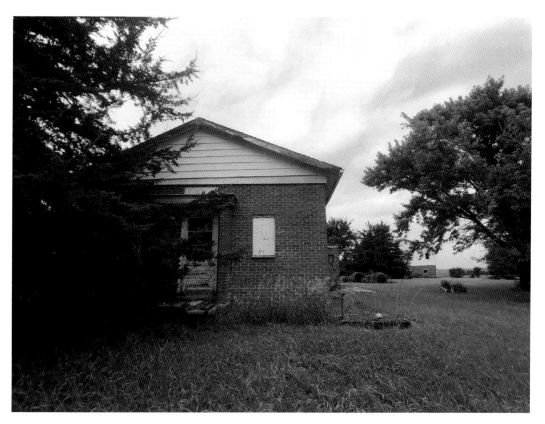

The front of Mary Ellen Observatory shows how plain of a house it was to have such extravagant things happen inside.

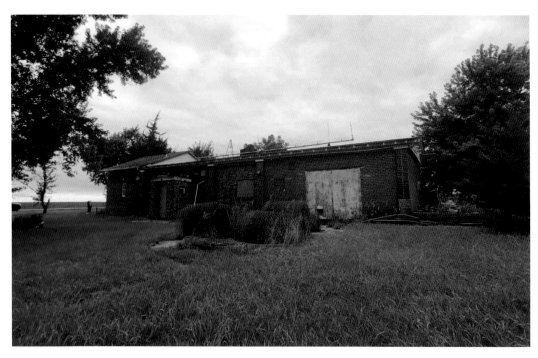

A side view of Mary Ellen Observatory showing a small number of antennas that were attached to the house.

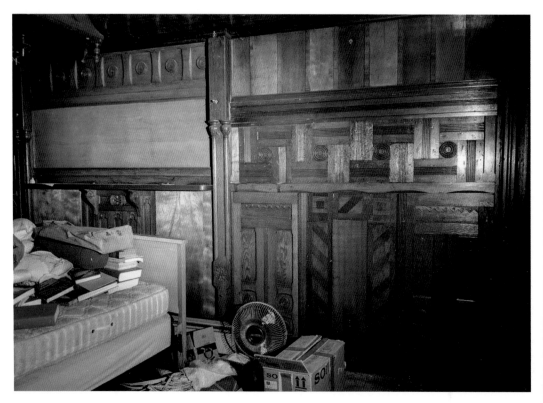

The interior was very detailed with random odds and ends—probably recycled materials. They had such an eclectic style.

# 14

# CHURCHES OF EASTERN NEBRASKA

**THE WILSON CHURCH** and original cemetery were founded in 1883 by Czech and German immigrants, but the current building replaced the original in 1918. Also known as Our Lady of Perpetual Help Church of the Catholic religion, it was added to the National Register of Historic Places in 1982. Regular services were last held in 1977. The steeple on this church is quite possibly the best one in Nebraska; you can see its elegance from quite a way down the old highway.

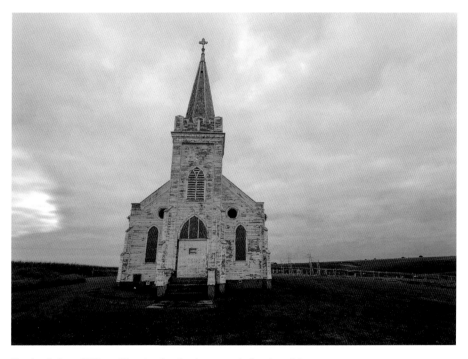

The front view of Wilson Church, showing how grand of a place it is.

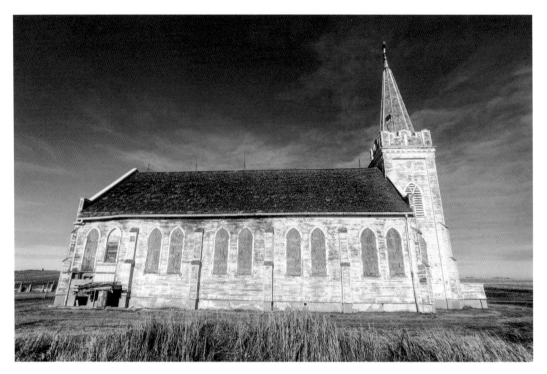

The side view of Wilson Church shows how nicely they tried to preserve where the stained glass once was by cutting the boards to the exact shape.

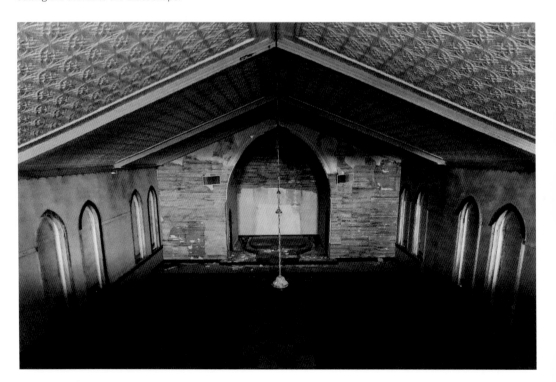

The interior sits empty, but all the different materials they used including tin ceiling and the checkered pattern down the center make this a very unique place.

**THE ZION CHURCH** was designed by M. P. Flechor, a Czech architect. It was constructed in 1887 as the first Czech Presbyterian church in the state. The cemetery was dedicated in 1875, and services were held in the church until 1975.

My favorite part about this church is the stained-glass windows. It is very rare to come across an empty church with some of them still intact. Most of them have been busted up by vandals leaving the owners to board up all the space where windows once were. Good news about this church though is that the most recent owner is working on restoring it to its original state.

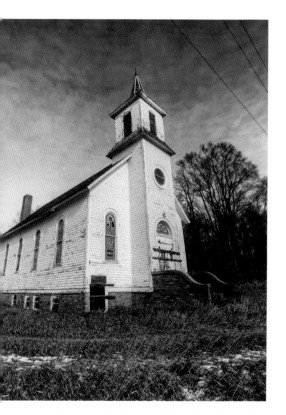 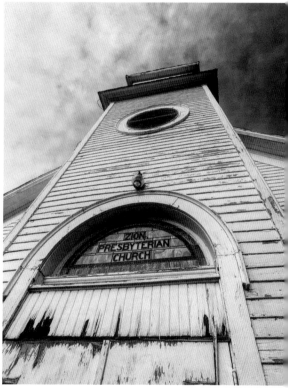

*Above left:* A side view of Zion Church, showing some of the architectural details.

*Above right:* A close-up shot of the stained-glass that is still intact.

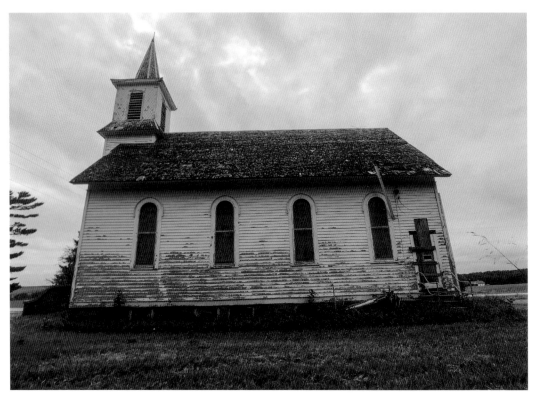

A side view showing again how they nicely covered the windows where the stained-glass once was.

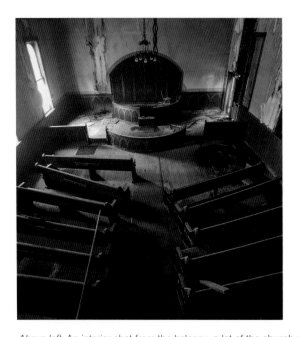

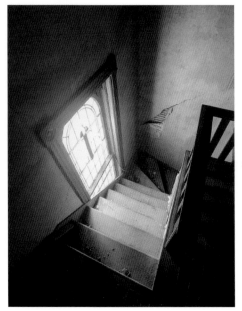

*Above left:* An interior shot from the balcony; a lot of the church pews still remain.

*Above right:* Going down the steps from the balcony showing one of the stained-glass windows that has not been damaged.

**THE OAKDALE CHURCH** was established in 1874 as a Methodist congregation, then in 1877, it became Presbyterian and in 1881, Episcopalian. The name of the town came about from the large amounts of oak timber in the area. Over the years, the church was used by all of those religions for services.

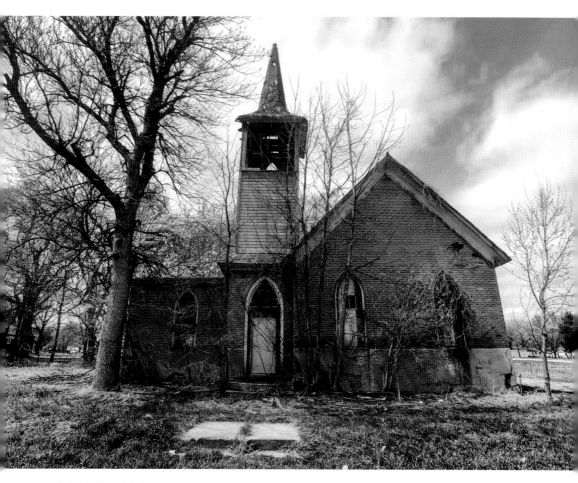

Oakdale Church is in pretty rough condition; the interior has nothing left but rotting wood.

**ST. MARTIN CHURCH** (also known as the Loucky Church) is a Roman Catholic church built to serve the Czech immigrant congregation. This gothic revival-style church was built by John E. King in 1907 and designed by architect James H. Craddock. It was added to the National Historic Register in 1985.

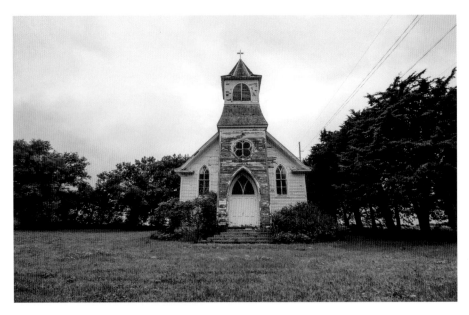

A front view of St. Martin Church showing how well-preserved and taken care of this property is.

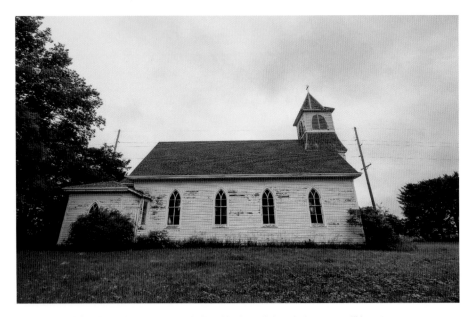

A side view of St. Martin Church; it is unbelievable that all the windows are still intact.

**THE ONG UNITED METHODIST CHURCH** was built in 1872, and in 1942, there was a big celebration for the seventieth anniversary.

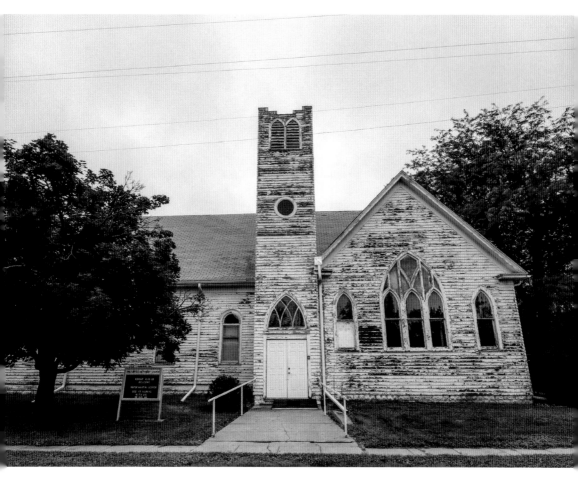

Ong Methodist Church is in fairly good condition minus the peeling paint.

**THE GETHSEMANE LUTHERAN CHURCH** in Ong was built in 1922 and originally served Swedish settlers, who moved the congregation from the nearby Edgar. This church is at the top of my favorites list for Nebraska churches. The shape reminds me of a castle; the fact that it is still standing strong today is amazing.

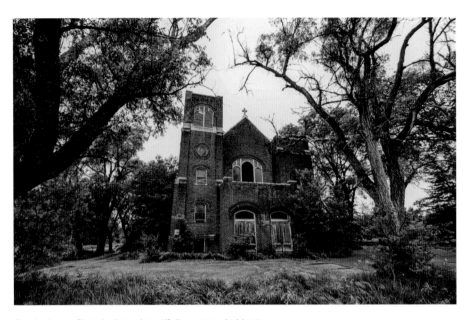

Ong Lutheran Church sits so beautifully surrounded by trees.

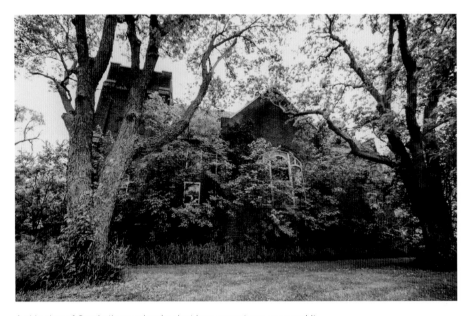

A side view of Ong Lutheran showing just how many trees surround it.

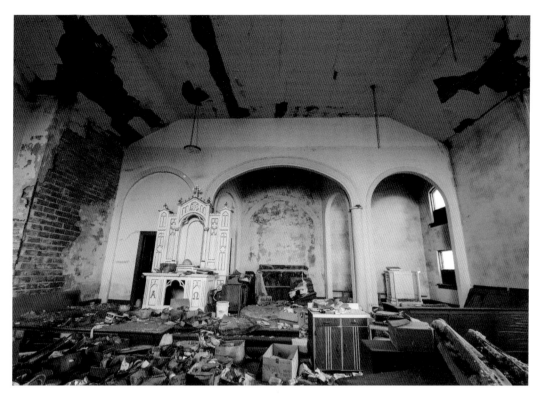

The interior is in pretty bad shape but still has a lot of interesting details.

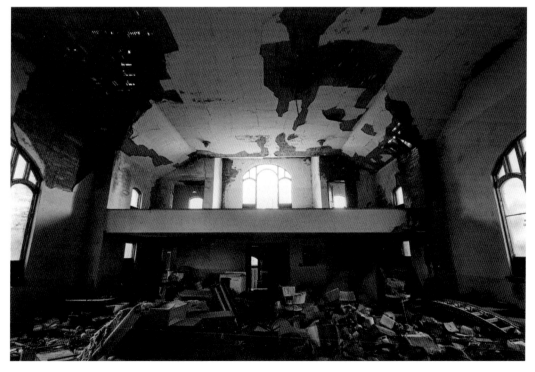

Another interior shot looking up at the balcony.

**THE SEWARD AREA CHURCH** was one of the first I ever visited in Nebraska. Unfortunately, I was unable to locate any information about its history. It sits on a corner at the bottom of a hill, and I remember driving up to it the first time and all I could see were the stunning stained-glass windows on the side. I immediately knew it would be beautiful.

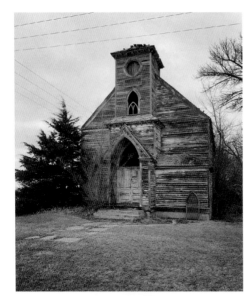

*Left:* Seward Church in the winter.

*Below:* A side view showing the beautiful stained-glass on Seward Church.

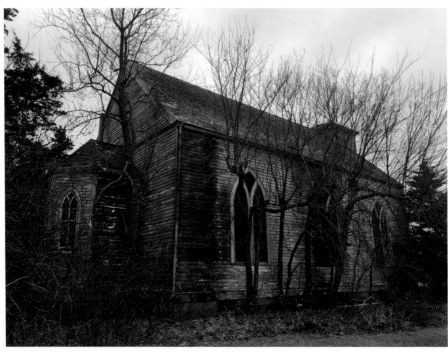

**THE MONOWI CHURCH** is very well-known to Nebraska photographers as the town has a population of only one. Elsie is eighty-five years old and is the mayor, bartender, librarian, secretary, clerk, and anything else you can imagine this little town would need. Monowi is the only incorporated town in the United States that has a population of just one.

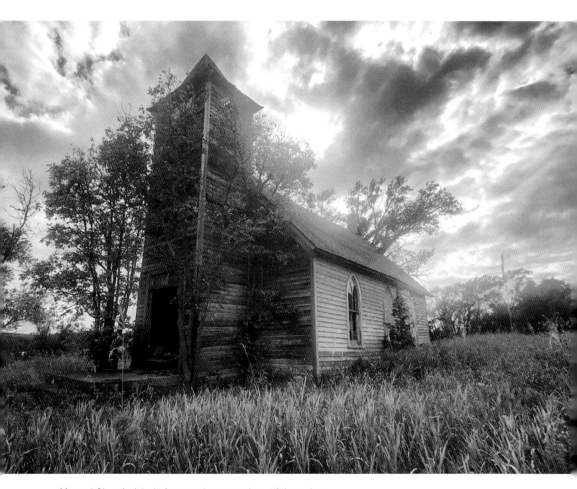

Monowi Church right before sundown on a beautiful evening.

**THE STEELE CITY CHURCH** was a random find. We were in the town checking out the old school and spotted this on our way out. The structure is in stunning limestone with a very unique tower. This church was built in 1882 and used by a Baptist congregation. The town has supported the inside with steel beams to help maintain the structure and preserve it for years to come.

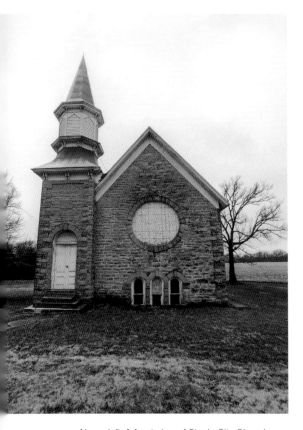 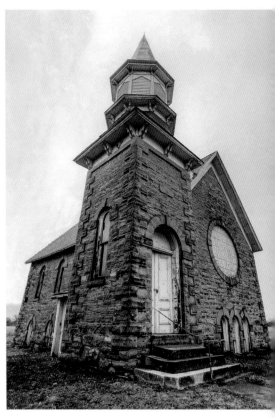

*Above left:* A front view of Steele City Church.

*Above right:* A different angle showing a lot of the detail on the tower and the trusses on the trim.

**KIMBALL CHURCH**, also known as First Church, was of the Methodist religion. Built in 1887, the land was given to the congregation by the Bay State Ranch, who bought it from Union Pacific.

The Methodists worshiped here until 1916 when the congregation grew too big for such a little church. This is when the Methodists built a new church and sold First Church to the Lutherans; it then became St. John's Lutheran Church. The Lutherans outgrew this church in 1954, and it has sat vacant ever since.

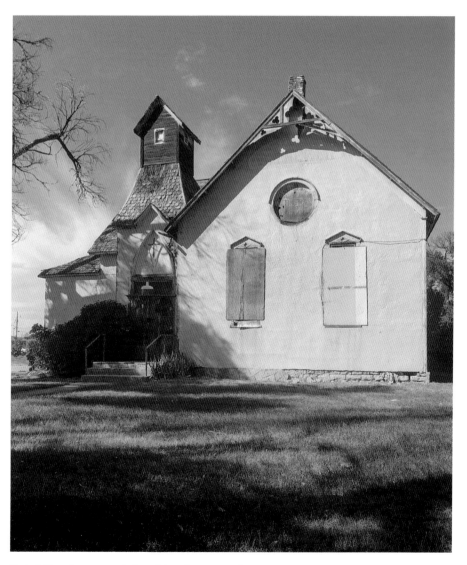

Kimball Church was so cute it could easily pass as a house.

**THE SARONVILLE CHURCH** was founded in 1872 by Lutherans and closed in 1986 due to declining membership. The church is now a private residence; as you can see in the photo, a lot of the original windows have been bricked over—to save on energy costs, I am sure.

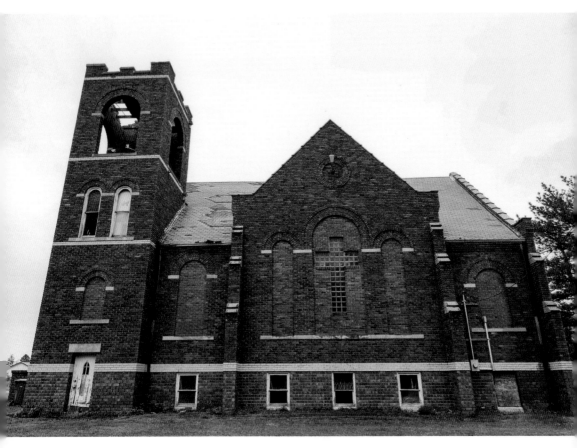

A side view of Saronville Church shows where a lot of the windows have been blocked in over the years.

# 15

# SCHOOLS OF
# EASTERN NEBRASKA

**THE NORTH BEND** area schoolhouse was a random find—one of those where your husband is driving and you spot it after passing then yell, "stop, turn around, I have to get pictures of that." The way it is tucked in the trees makes it almost impossible to spot in the green months. I was unable to find any dates on this school, but it seems to have been closed for quite some time now. From the looks of it, I think the current owners used it as horse stables at one time as the back has been completely cut up and divided into weird stalls.

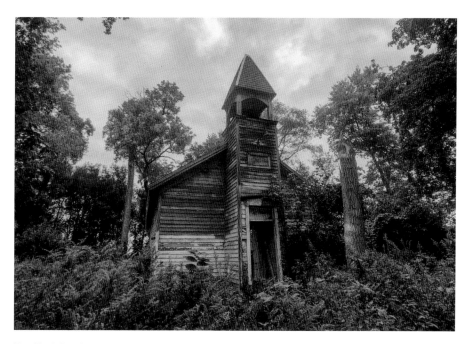

The North Bend schoolhouse sits completely tucked away in a wooded area.

**THE EMPORIA SCHOOL** is by far one of my favorite one-room schoolhouses. I was unable to locate any specific information on it, but someone still cares. When you arrive, the lawn is well maintained and manicured; it sits practically in the middle of nowhere on a corner lot. The inside was full of a lovely patina and natural decay. No vandals have found this gem yet luckily.

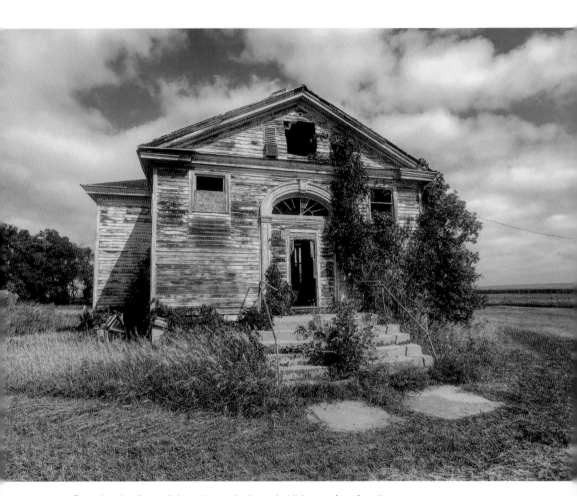

Emporia schoolhouse is in pretty rough shape, but it is one of my favorites.

**BELDEN PUBLIC SCHOOL** was built in 1924 and took children from kindergarten all the way through to high school until 1966 when the high school merged with Randolph Schools. Belden continued to have elementary classes until 1999; that was the last graduating class before the building closed for good. The town population now is roughly 100. The inside is in pretty terrible shape; the cement steps are even starting to crumble.

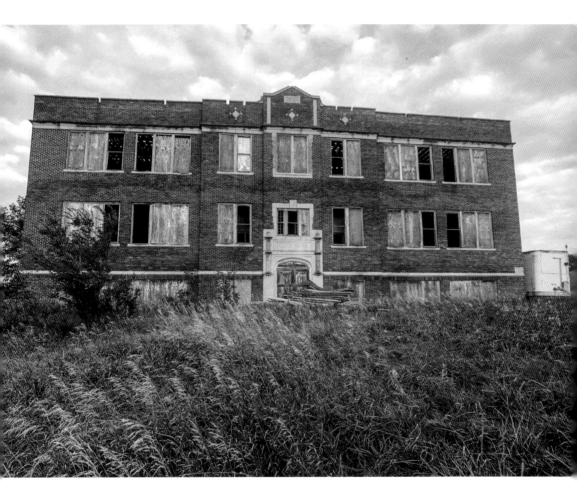

Belden School looks to be standing strong from the exterior.

*Left:* Once you get inside, you see how crumbly it really is.

*Below:* This was taken on the third level, and it was by far my favorite spot to see all the foliage starting to grow inside.

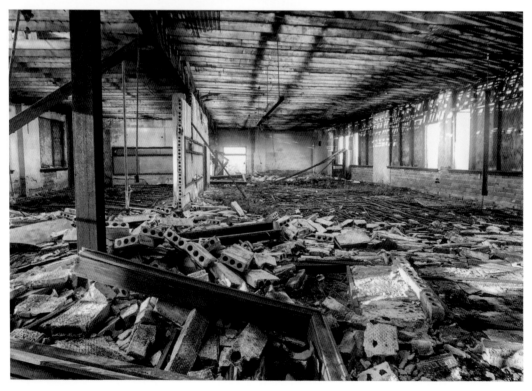

**STEELE CITY SCHOOL** was built in 1914 and covered elementary through to high school. The high school portion closed in 1958, and the elementary classes continued until 1992. The Jefferson Country Historical Society owns the building now and seems to be maintaining the structure well.

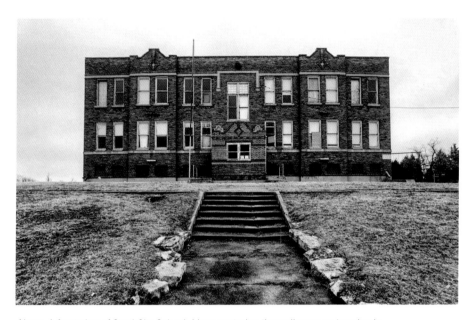

*Above:* A front view of Steel City School; I love capturing the walkways up to schools.

*Below:* Looking down into the Steele City gym from a broken window in the back of the school.

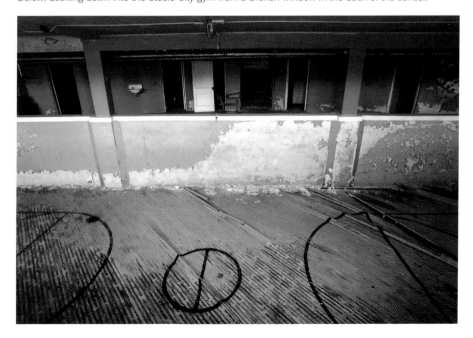

**THE BLACKSTONE SCHOOL** sits at the top of a hill down a minimal maintenance road far away from anything else. The land is now used for farming, and the farmer is so awesome to leave the school how it is and not demolish it for more farming space. The structure of this school is so unique by how its caving in smack dab in the middle of the roof line. I am not sure what causes this to happen, but I have seen photos of similar-shaped schoolhouses in other states that are collapsing in the exact same spot.

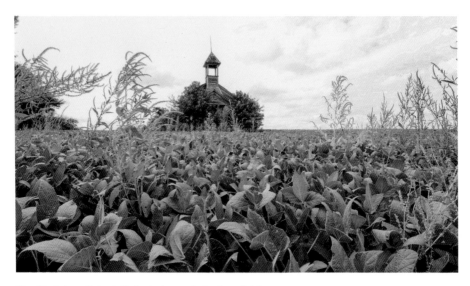

The Blackstone School sits tucked away in the beanfield.

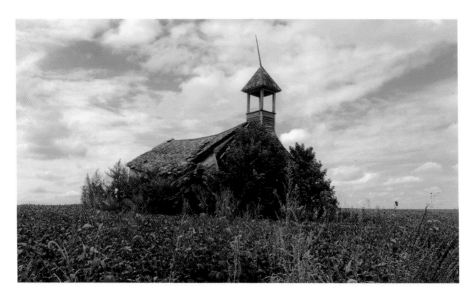

A closer look at this beautiful schoolhouse shows how the roof is collapsing in the middle.

**ELK CITY SCHOOL** was built in 1931 and was known as district eight. It was a two-room school that once held classes for kindergarten students through to the eighth grade. There were roughly twenty students in total. The school did not have a lunch program, so kids either went home over lunch or brought a sack lunch. They did do a potluck once a month as well. Every morning, two students would go outside to carefully raise the flag, making sure it did not touch the ground. The merry-go-round in the back was also a big hit along with the big Christmas program they held every year.

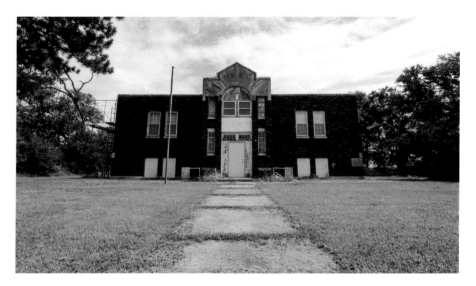

A front view of Elk City School.

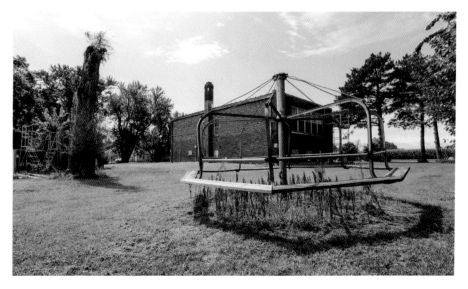

A back view of Elk City School, showing the old wooden merry-go-round.

**BEE SCHOOL** closed in May 2005 due to enrollment declining in the area. During the last school year, there were only eight students in the kindergarten to eighth grade program. Now that the school has been closed, all students living in Bee either go to East Butler for high school and junior high then Brainard and Dwight for elementary. According to my research, everything has been left boxed up in the building ready to fill another school if need be. Everything from books to classroom supplies are all still there.

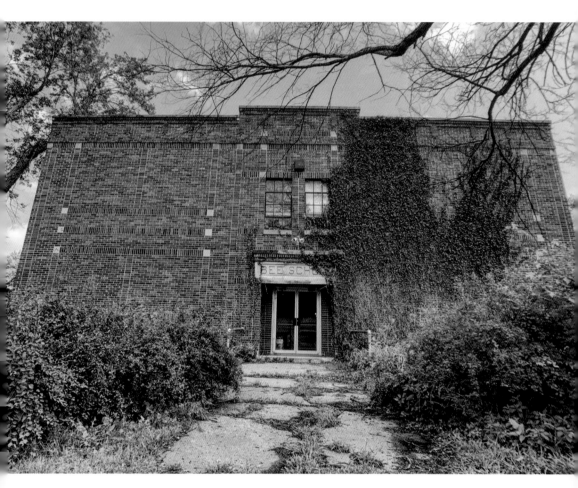

A front view of Bee School, showing all the lovely foliage.

**ST. MARY'S CATHOLIC SCHOOL** opened in 1914 and closed in 1942. It reopened following World War II for another fourteen years before closing for good. This school sits on a dead-end road at the edge of town. On the same road are two other schools that are no longer in use as schools but are used for other purposes. This one, on the other hand, is sitting empty and rotting away unfortunately.

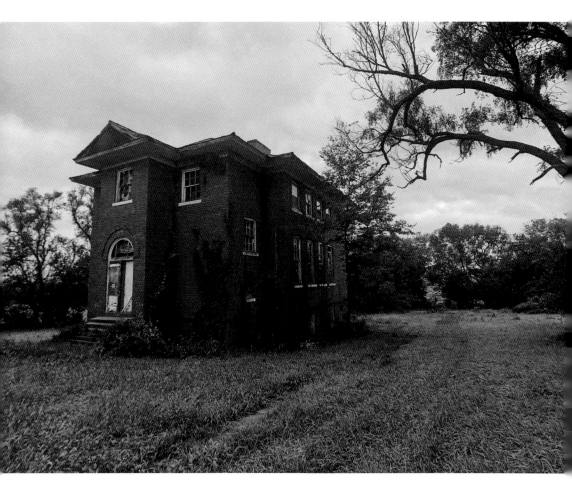

St. Mary's Catholic School sits all alone at the end of the road.

**LAMB SCHOOL** was built in 1928 as district two. The very first time I went here, the place was still in pretty good shape minus the normal deterioration from sitting empty for so long, but the next time I visited, it was very sad to see the state it was in. Recent flood damage caused the back wall to cave completely off, but following research, the owner is trying to repair the damages done and get this school back to being a well-preserved historical site. We cannot thank these owners enough that try and preserve these historic buildings that they own.

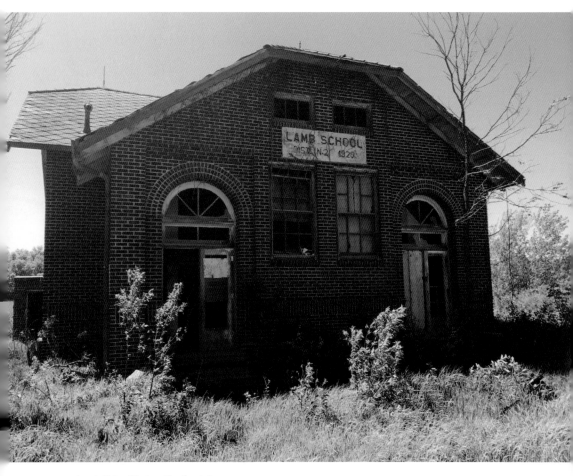

Lamb School before the flood damage.

**DISTRICT 118 SCHOOL** is the closest one-room schoolhouse to where I live, so it has been a frequent stopping point. The last time I went, we were on our way to the lake and the sunset was beautiful, so I said, "we have to stop." I am sure glad we did because the owner came driving up as I was getting my shots. He was thrilled to see I was just taking photos as he has had to chase vandals out recently. He lives right down the road, and you can see his place from the school; the land it sits on is also farmed. He was in the last class in 1962, then years later, he and his wife bought the adjacent property that their house sits on along with the school.

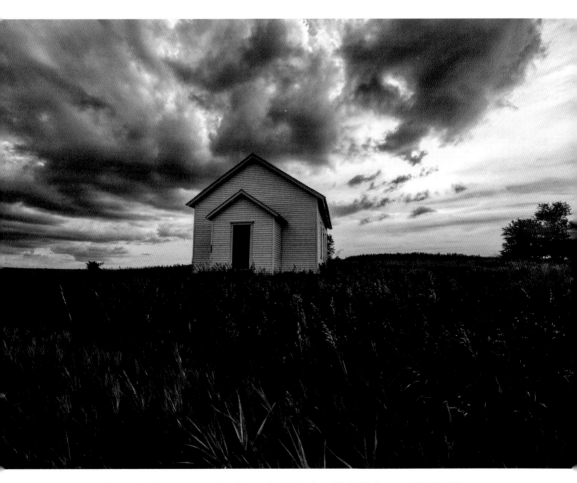

District 118 is a simple one-room schoolhouse that looks beautiful with the sunset behind it.

**STRANG SCHOOL** was built between 1929 and 1930 and is district thirty-six. The current building replaced the original schoolhouse that burned in 1928. The school was used as a high school from 1930–1951, then was kindergarten through to eighth grade until 2006. It was added to the National Historic Register in 1992. The building is renaissance revival style, which means it has two stories with a flat roof.

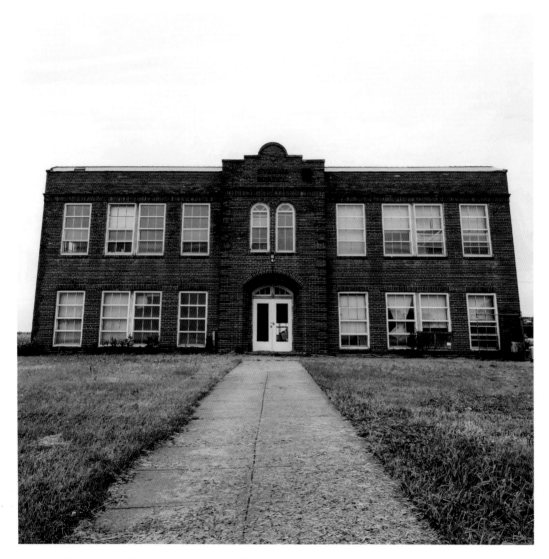

A front view with the walkway up to Strang School.

**ONG PUBLIC SCHOOL** is right down the street from the abandoned Lutheran church. In fact, the entire town can probably be seen standing in front of the school, which is now a private residence. The towns students now go over to Shickley as Ong only has a population of about sixty.

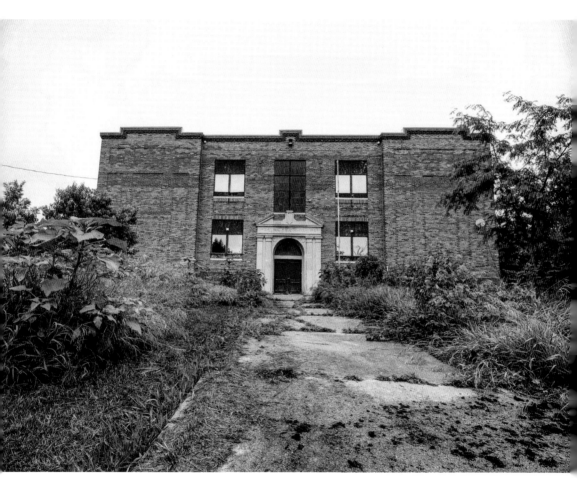

Ong School, although turned into a home, though you would not guess it by the looks of the lawn care.

**PIERCE SCHOOL** is now just ruins resembling what once was. This one-room schoolhouse held classes until the mid-1960s, then sometime in the 1980s, there was a fire, leaving it in the state it currently sits.

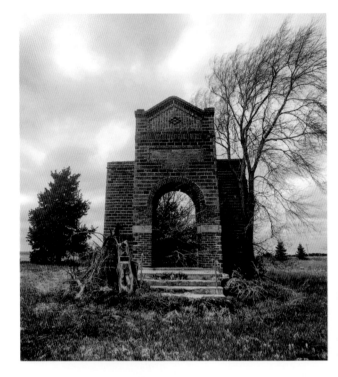

*Left:* A front view of Pierce School.

*Below:* A side view shows the extensive damage from the fire.

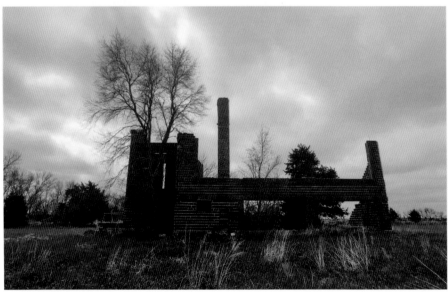

**SUNNYSIDE SCHOOL** in district thirty-five closed because the communities could no longer support a small school and were forced to consolidate and move children to bigger town schools.

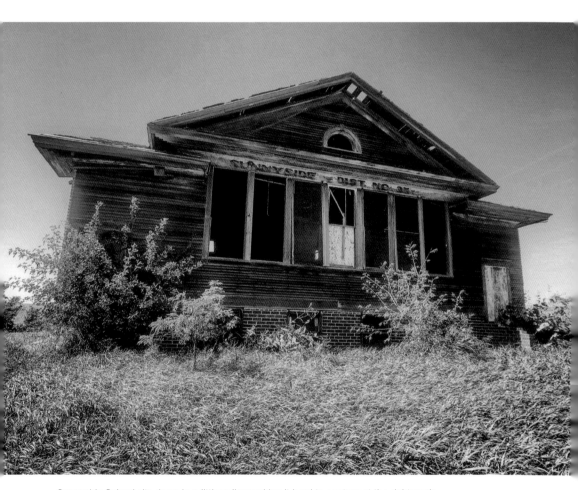

Sunnyside School sits down in a little valley making it hard to capture at the right angle.

**OAKDALE HIGH SCHOOL AND ACTIVITIES BUILDING** are positioned right next to each other on the outskirts of town. The activities building was built in 1919 to hold community activities, and in 1921, the gymnasium and auditorium were added to the same structure. The high school was built in 1912. In the 1930s, this town hit an economic drought and never really sprung back. The activities building still sits empty today, while next door, the high school has become a home that has been very well kept up and preserved.

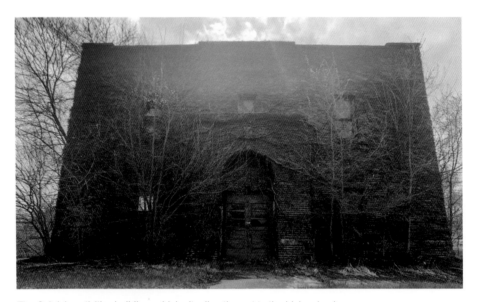

The Oakdale activities building, which sits directly next to the high school.

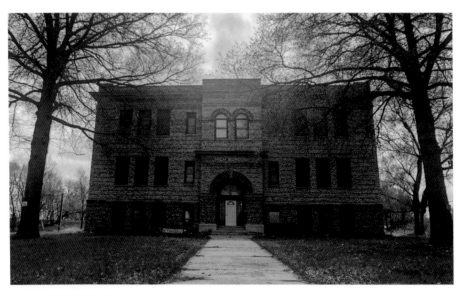

Oakdale High School, which is now a private residence, is maintained so nicely.

**LINWOOD SCHOOL** was built in 1865, and in 1963, a flood devastated the town, forcing the school to close. The students now go to Schuyler or David City schools. This building is pretty intact for sitting empty as long as it has. Someone is definitely keeping up on maintenance, which is always a plus; we hate to see these historic buildings go into disrepair.

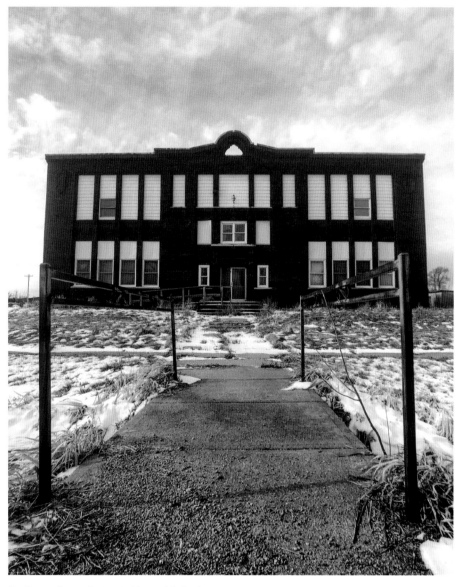

Another walkway shot up to Linwood School.

# ABOUT THE AUTHOR

**NICOLE RENAUD** has been photographing the forgotten for over a decade. It all started with the surrounding areas of her hometown of Lincoln, Nebraska, and quickly grew to weekend outings to neighboring states and planning her trips around photographing spots. She owns four dogs and five cats and lives with her husband, Michael. Together, they travel as much as they can and always find adventure. Her other hobbies include anything related to animals and she almost always is dog-sitting for someone. Find her on Instagram @rural.wandering.animal.lover